MICHIGAN STATE
FOOTBALL

They are Spartans

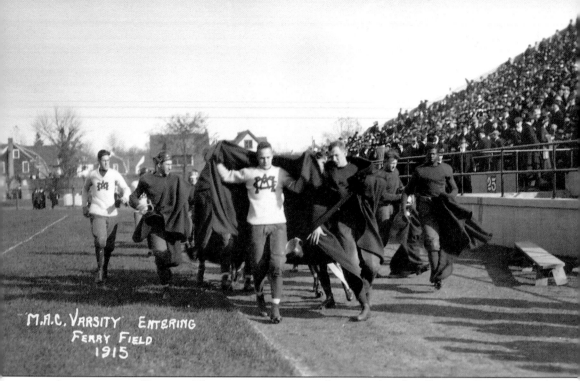

M.A.C. Varsity Entering
Ferry Field
1915

ARRIVING FOR BATTLE. The men representing the agricultural college in East Lansing, Michigan, on the football field had a noble air about them long before the institution was known as Michigan State University and they were called the Spartans. And nothing made them march a little prouder or raise their heads a little higher than an impending confrontation with their archrival, the University of Michigan. On October 23, 1915, the Michigan Agricultural College Aggies, led by standout tackle Gideon Smith (far right), strode confidently, and with capes flowing, onto UM's Ferry Field for a monumental showdown. From 1898 to 1914, MAC had won just once, in 1913, by the score of 12-7 in Ann Arbor, where 44 of the first 50 meetings took place. It's no wonder the mostly friendly animosity that exists between the two schools is deeply rooted. The Aggies beat Michigan for the second time on this October day by a score of 24-0, and the events quickly became known back home as "The Slaughter."

MICHIGAN STATE FOOTBALL

They are Spartans

Steve Grinczel

ARCADIA
PUBLISHING

Published by Arcadia Publishing
Charleston SC, Chicago IL, Portsmouth NH, San Francisco CA

Printed in the United States of America

Library of Congress Catalog Card Number: 2003114744

For all general information contact Arcadia Publishing at:
Telephone 843-853-2070
Fax 843-853-0044
E-mail sales@arcadiapublishing.com
For customer service and orders:
Toll-Free 1-888-313-2665

Visit us on the Internet at www.arcadiapublishing.com

CONTENTS

ACKNOWLEDGMENTS

I would like to express my deepest gratitude to Michigan State University Assistant Athletics Director for Communications John Lewandowski, Sports Information Director Becky Olsen, Assistant Sports Information Director Matt Larson, and especially Sports Information Department office assistant Paulette Martis for their invaluable assistance, advice, and patience. Also, thanks to Steve Jowett and Harley John Seeley of MSU's Instructional Media Center. And sincere thanks to Joyce, Meghan, and Sam for your love and support. Rights fees were paid to Michigan State University for the use of the photographs and images in this book.

For Sophie and Edmund, who somehow, someway
made everything possible.

INTRODUCTION

Not so very long ago, a Lansing television station interviewed former Michigan State University basketball standout Charlie Bell about what various ex-players were doing with themselves during the summer months. Bell explained that some were working out to get in shape for tryouts with professional teams, while others were honing their games for the upcoming season. A few were competing in tournaments outside of the country. Lastly, Bell emphasized that they continued to work so hard because they were still playing for the "Spartans all over the world."

It's undoubtedly true that alumni and fans of colleges and universities everywhere care for their school every bit as much as those affiliated with Michigan State. And yet, it's not often that you run into people who identify as closely with the nickname, and the image it projects, as folks from Michigan State do. They are Spartans and routinely refer to themselves as such. The athletes, especially those who bring glory to their school, are Spartans of the highest order. As passionate as Michigan faithful are to their institution and teams, you rarely hear one say, "I'm a Wolverine for life." Most of those who are attached to Ohio State probably wouldn't say, "I come from a long line of Buckeyes." A group of Wildcats could involve devotees of Arizona, Kansas State, Kentucky, and Northwestern, to name a few. If you're from North Carolina State, do you say, "I plan to die as a Wolf, a Pack or a pack of wolves?"

That's not to say Spartans corner the market on identifying closely with their moniker. Certainly, there are those who will insist on going into their respective halls of fame as Vols, Tar Heels, Gamecocks, Crimson Tides, Scarlet Knights, Fighting Irishmen or Irishwomen, Fighting Illini, the Cardinal, Cardinals, Ducks, Beavers, Gators, Longhorns, Bearcats, Golden Bears, Golden Eagles, Golden Gophers, Golden Flashes, Golden Hurricane, Hurricanes, Cyclones, Sun Devils, Blue Devils, Blue Demons, Yellow Jackets, Mean Green, Green Wave, Orangemen, Red Raiders, Jayhawks, Hawkeyes, Vandals, Zips, and Banana Slugs. Then again, maybe not.

Members of the Spartan fraternity never seem to shy away from being called what they are. In fact, they insist. Of being a Spartan, an ancient unknown scribe once wrote, *"Once we were powerful men. We are now powerful; Try if you like, but we shall become better than you."* Perhaps the affinity is borne of a history of turmoil, conflict, conquering foes—real and imagined—and being conquered. That's certainly been the case at Michigan State since it was founded in 1855 as Michigan Agricultural College (MAC), east of the state capital in Lansing, on the banks of the Red Cedar River. Students started playing organized football at the club level 29 years later. The school's early mission was to provide practical education in areas such as farming and other non-intellectual disciplines. Meantime, 65 miles to the southeast, the University of Michigan was turning out graduates versed in arts and letters. In a sense, UM was the handsome, well-appointed big brother, and MAC was the scruffy underling, always under foot, under-appreciated and annoying. It didn't help that while Michigan was gaining prestige nationally as a football power, Michigan State was winning its first varsity games against the likes of Lansing High School.

When the teams faced each other for the first time in 1898, Michigan rubbed the upstart's nose in a 34-0 defeat. In the rematch four seasons later, UM won, 119-0. For the next three

meetings, Michigan sent its freshman team. As years went by, and MAC matured into Michigan State College and then Michigan State University, the gap between the schools closed considerably both academically and athletically. Nevertheless, Michigan State earned a reputation for never feeling quite up to Michigan's level even though it offered many of the same scholastic and sports programs, and had the upper hand in football in the 1950s and '60s. This became known as MSU's infamous inferiority complex. Michigan, on the other hand, was perceived as being snobbish, if not insufferably arrogant. Consequently, to this day, MSU's self-esteem is never higher than when it beats Michigan, while Michigan is never so wounded as when it suffers the indignity of losing to the unworthy Spartans. From a rivalry standpoint, who could ask for anything more?

Footballwise, the Spartans rose to national prominence under the guidance of President John Hannah, who considered the attention athletics—particularly football—brought schools as a means to get his institution noticed. And it worked. While in the process of wedging itself into the Big Ten and winning six national championships, Michigan State also grew into a major research center and one of the nation's largest universities both in terms of enrollment and acreage. The football empire has not always been as fruitful. There was the Golden Age of the Spartan Gridiron, lorded over by legendary coaches Biggie Munn and Duffy Daugherty, and the seasons that followed, which have been punctuated by not enough incredible highs and far too many unbearable lows.

There is a sense that Michigan State will never be able to compete with established regional powers like Michigan, Ohio State and Notre Dame because it can't come close to matching their tradition. That, as it turns out, is nonsense. From Ex Exelby, to Gideon Smith—an African-American player who not only starred for but was celebrated by MAC in the 1900s—to Carp Julian, to the longstanding mutual respect that exists between MSU and Notre Dame, to giant John Macklin and tiny George "the Wolverine Killer" Gauthier, to Jim Crowley—one of the famed Four Horsemen—to the Pony Backfield, to Biggie and Duffy, to Dick Kaiser's Rose Bowl-winning field goal, to Ellis Duckett's blocked Rose Bowl punt, to The Game of the Century with Notre Dame, to Eddie Brown's defense on Michigan's 2-point conversion, to T.J. Duckett's game-winning catch against the Wolverines with no time left . . . there is no shortage of Spartan tradition.

Although Michigan State hasn't won nearly as many games or championships as mighty Michigan, the Spartans do have a penchant for keeping pace with the Wolverines in the national consciousness. Whether it's with stunning upsets, like beating top-ranked Ohio State in 1972 and again in 1998, and No. 1 UM in 1990, or with attention-grabbing individual sportsmen or some newsworthy—not always flattering—development, Michigan State maintains a profile that's occasionally disproportionate to its football success. Michigan, for example, has no one as universally popular as MSU basketball icon Magic Johnson. Furthermore, players like Charles Rogers, T.J. Duckett, and Kirk Gibson have kept MSU's name in the forefront in recent, sometimes lean, years. And of all the tremendous showdowns that have involved Michigan for more than 100 years, the Wolverines have no one single game that is remembered, revered, and still debated the way Michigan State's 10-10 tie with Notre Dame in 1966 is. And that's why despite occasional spells of self-induced trauma, those associated with MSU know there is something special about being able to say they are Spartans.

ONE

The Early Years

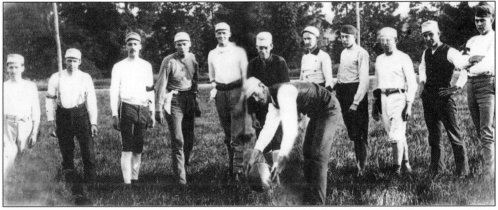

THE FOREFATHERS. Michigan Agricultural College fielded its first football team in 1884, but the school didn't recognize football as an organized varsity sport until 12 years later. In the meantime, the Michigan Aggies participated in multi-sport, Olympic-style field days held at colleges across the state. Rolla C. Carpenter (far right), a professor of mathematics and civil engineering, coached the team.

Officially sanctioned football had an inauspicious debut at MAC. The Aggies ended their first season with a losing record. They rebounded with a pair of winning seasons and the appetite for a winning football team had been whetted. After losing to Alma College, 23-0, to finish the 1900 campaign with a 1-3 record, a writer in the M.A.C. *Record*, the school newspaper, provided insight into the mind-set of the day by lamenting: "Why is it that our present team fares thus? Out of a student body of nearly 500 can we not find material equal to that picked from a much smaller institution? Most certainly we can. We have material of the very best kind. In weight, our team, with one exception, has equaled every eleven played. In individual playing we have excelled the other teams, but in team work we have been far deficient."

By 1902, school administrators came to the conclusion that if they're going to have a football team, they should field a winner or not play all. After getting humiliated by the University of Michigan, 119-0, MAC president Jonathan L. Snyder groaned, "If we must have football, I want the kind that wins."

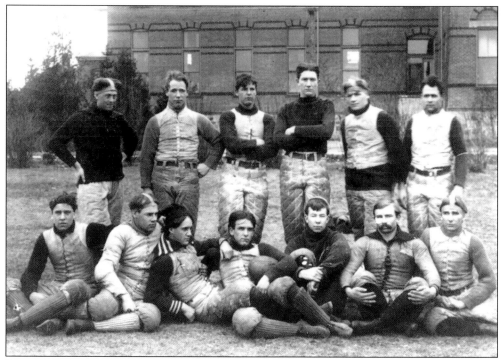

PRESENTING THE 1896 VARSITY. The initial MAC varsity football team had no established coach. Michigan State football debuted on September 26, 1896 with a 10-0 victory over Lansing High School. Spartan Stadium, the current home of the Spartans, is located just west of where an Indian encampment existed on the southern bank of the Red Cedar River in the mid-1850s.

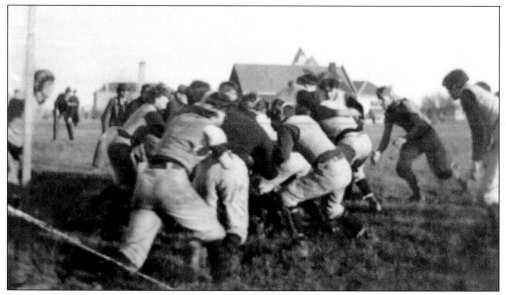

GAME ACTION. This is one of the earliest known photographs of Michigan State football game action. It was taken during MAC's 18-16 home-standing loss to Alma College on November 11, 1896. Some of the players wore crude headgear and shinguards. MAC finished the season with a 1-2-1 record which included a previous 0-0 tie with Alma and a 24-0 loss to Kalamazoo College.

RAISING THE BAR. Michigan State Agricultural College hired Henry Keep to be its first varsity football coach in 1897. Details about Keep are sketchy, but what's known is that he was an engineering student who also coached the track team. More importantly, Keep was a winner. He posted a 4-2-1 record his first season and a 4-3 mark during his second, and final, campaign.

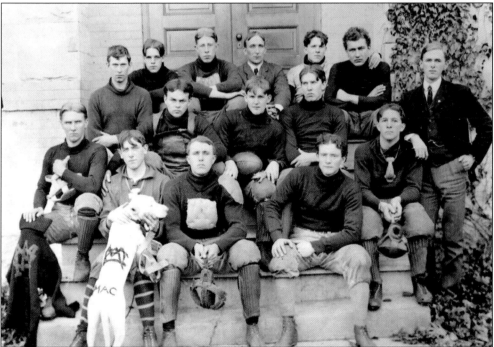

TOUGH TIMES. By 1900, the Aggies were smartly attired in uniform sweaters (held by player on far left) bearing the intertwined MAC emblem. They had an adoring, logo-bearing mascot, too. However, a 23-0 loss to tiny Alma College in the season finale left the Aggies with a 1-3 record that did not sit well with the student body.

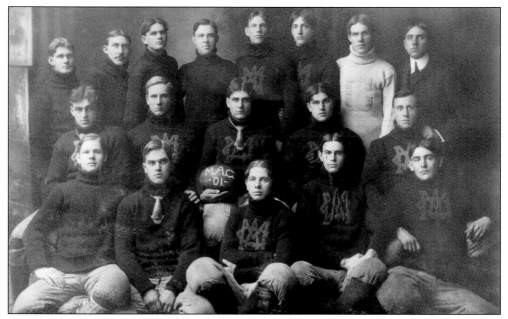

A Familiar Ring. George Denman (back row, second from right) became MAC's third coach in 1901and led the Aggies to a 3-4-1 record. The season wrap-up written in the M.A.C. *Record* could apply to the big-time, money-draining football programs of today: "In reviewing the football season just ended, many things come to the surface which show the need of a radical change in the Department of Physical Culture. To make a success in any line of athletics, spirit, money and time are needed in no small amounts. . . . All three were conspicuously absent and everything was at a standstill." Denman was out as coach after the Aggies went 4-5 in 1902.

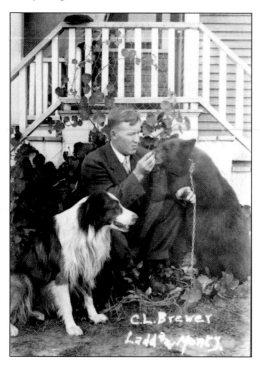

Turning Things Around. In 1903, Chester Brewer, shown with school mascots Ladd the dog and Monty the bear in 1908, became the head coach of a Michigan Agricultural team that lost to Michigan by the score of 119-0 the previous year. A former four-sport star at the University of Wisconsin, it didn't take Brewer long to meet the challenge of turning around MAC's sagging fortunes. An advocate of sportsmanship and clean play, Brewer's first team finished with a 6-1-1 record.

FARMERS VS. CATHOLICS. On a postcard bearing his photograph, Aggie left end Fred Stone wrote this missive to Mr. A.L. Campbell in Arapahoe, Wyoming, prior the 1910 home game against Notre Dame: ". . . we fight tomorrow and 24 hours from today it will all be over. Wish us luck Art for we need it. My knees are wobbly. Stone."

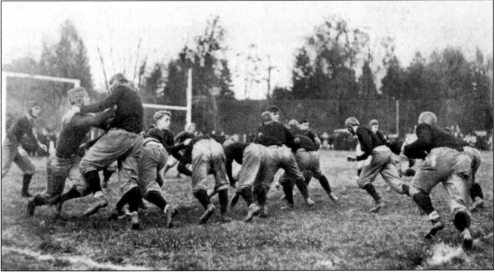

FIGHTING THE IRISH. It was billed as "the most important game" MAC was ever to play in East Lansing, and extra bleachers and box seats were erected for it around College Field, by the Red Cedar River. On October 29, 1910, some 4,000 spectators paid from 50 cents to $1.50 per ticket to watch the Michigan Aggies play Notre Dame. Some alumns reportedly traveled more than 500 miles to attend and they weren't disappointed. The Fighting Farmers, an unofficial nickname, ended an eight-game losing streak against Notre Dame with a 17-0 victory. "We were simply outclassed," Irish coach Shorty Longman said. "MAC is vastly underrated. There is no team in the West that can defeat the Farmers on their own field."

13

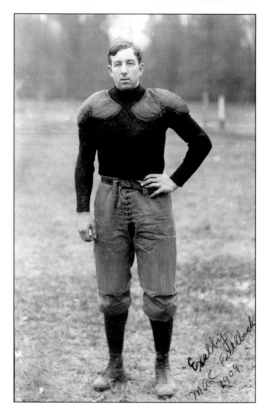

EX-CEPTIONAL. Fullback Leon "Ex" Exelby was one of MAC's first players to be recognized as a star. He was named to Eckersall's 1910 All-Western Eleven and tasted defeat only twice in three seasons.

A GIANT'S STEPS. Big even by today's standards, the 6-foot-7, 275-pound John Macklin was a giant of a man. A standout all-around athlete at the University of Pennsylvania, Macklin towered over most of his players, and soon over the program. Macklin won 29 of the 34 games he coached for MAC from 1911 to 1915. His were the first Aggie teams to defeat Ohio State (1912), Michigan and Wisconsin (1913), and Penn State (1914). Macklin coached MAC's first All-Americans and was 2-3 against Michigan. His .853 winning percentage ranks second among Michigan State coaches.

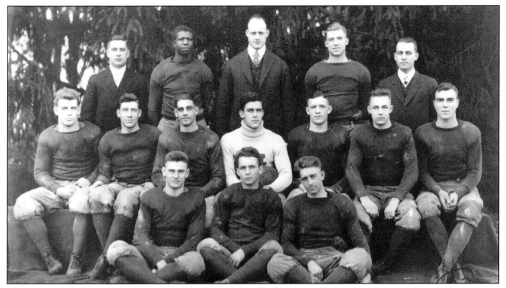

Defeating the Conquering Heroes. MAC fans watched in delight when their great sophomore end, Blake Miller (second row, third from left), gained 8 yards and a first down on a fake punt before being tackled near the end of the first half of the 1913 game at Michigan. Joy turned to horror, however, when Wolverine quarterback Tommy Hughitt ran 20 yards out of his way and landed on Miller's neck with both knees and knocked him unconscious, according to former Michigan State sports information director Fred Stabley's book, *The Spartans*. Stabley also cited a Michigan official's outrage, but at the referees for not dealing with the misconduct. Miller spent the next three hours in the hospital before waking up. Meantime, his brother, Hewitt (front row, far right) scored the decisive touchdown on a 46-yard fumble return early in the second half. Hewitt then preserved the 12-7 win when he knocked the ball out of a UM receiver's hands with a bone-jarring hit at the goal line with little time remaining.

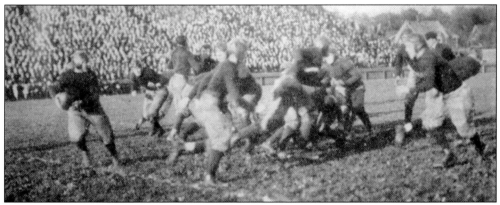

"The Wolverine Killer." Coach John Macklin initially told George Gauthier he couldn't join the MAC football team because he stood just 5-foot-6 and weighed only 133 pounds. Macklin eventually was glad he relented. Gauthier led MAC to its first win over UM in eight tries, and according to newspaper accounts, Michigan's 1913 team lost to the Aggies, 12-7, because it couldn't "cope with forward passes" thrown by "the little Detroiter" and his "basketball tactics." Referred to in one headline as "The Wolverine Killer," Gauthier completed 7 of 19 passes for 100 yards, which was a remarkable feat considering the ball was still years away from being streamlined for throwing.

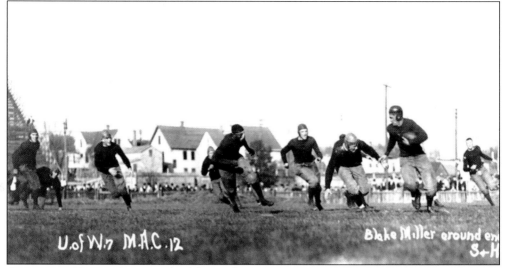

OVER THE HUMP. Aggie end Blake Miller scurries around left end while MAC tackle Gideon Smith (wearing a noseguard) prepares to throw a block against Wisconsin, which was considered much more powerful than the Michigan team MAC defeated the previous week. Perhaps, but the final score was the same as Miller scored the first touchdown in the 12-7 win over the defending Western Conference champion Badgers. The 7-0 Aggies went on to win their final three games to finish undefeated and untied for the first time in school history.

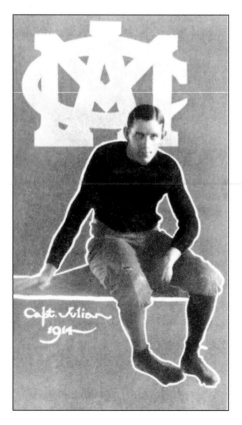

RAH! CARP! RAH! JULIAN! RAH! RAH! CARP! JULIAN! Arguably MAC's first All-American, team captain George E. "Carp" Julian was in 1914 proclaimed "one of the greatest fullbacks that ever donned football togs." Thirty-three years later, former teammate Gideon Smith told *The Lansing State Journal*, "Goodness me, he could tear a barn down with his bare hands. I never did see a man who gave so much of himself to the game. If there's anything wrong with the present day football player it's that he doesn't try hard enough—he saves himself too much." Julian scored seven touchdown in a 75-6 win over Akron and according to a *State Journal* article, Julian's "ability to hit the line like an untamed thunderbolt, peerless tackling power, cool headwork, and . . . play like a demon all the time. . . ." is why he was named to Walter Eckersall's 1913 All-American team, which was not recognized by the NCAA.

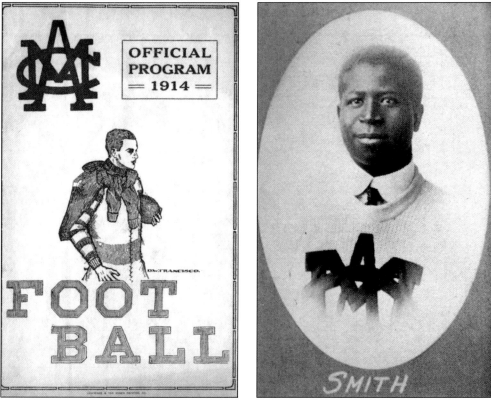

PIONEER. A portrait of tackle Gideon Smith appears on page 15 of the Michigan Agricultural College Football Program as though it was the most natural thing in the world to prominently promote a black player in 1914. Smith was MAC's first African-American athlete and believed to be only the nation's third black college football player. When Smith decided to go out for football in 1912, MAC Coach John Macklin wouldn't issue him a practice uniform, effectively preventing Smith from joining the all-white Aggies—or so Macklin thought. But after a future teammate's friend—a veterinary student named Chuck Duffy—loaned Smith his old high school uniform, Smith reported for practice and eventually won Macklin over with his rugged play. According to end Blake Miller, who lined up next to Smith, the abuse he took from opponents was unprintable, but Smith just kept quiet and did his job, eventually earning the respect of friend and foe alike. After the 1915 season, Smith was named to All-Star teams picked by the *Chicago Daily News* and *Collier's Magazine*. He continued to play that season in professional football, joining Jim Thorpe and the Canton Bulldogs just in time to face former Notre Dame stars Knute Rockne and Gus Dorais of the Massillon Tigers. After gaining acclaim as one of pro football's first black players, Smith served as the head football coach at Hampton Institute for 34 years.

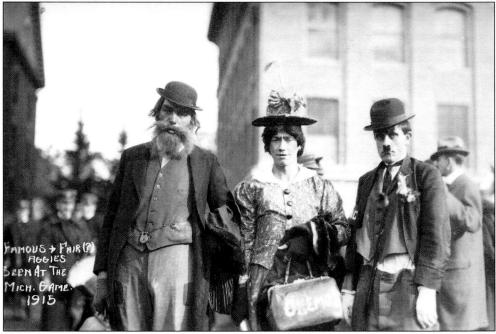

FAN-TASTIC. Fans dressing up to draw attention to themselves at football games is hardly a new phenomenon. For the 1915 game at Michigan, MAC fans came as silent-screen star Charlie Chaplin and friends.

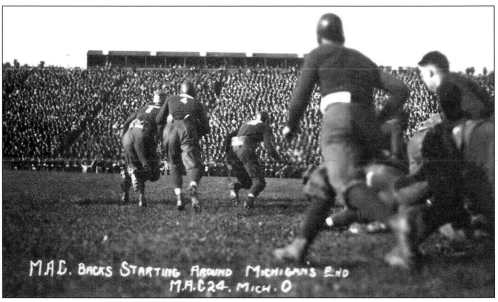

ON THE RUN. MAC's backfield, featuring the school's first official All-Americans—fullback Jerry DaPrato and halfback Blake Miller—ran roughshod over the Wolverine defense in the Aggies' stunning 24-0 victory in 1915. Miller, an elusive open-field runner, was so impressive while gaining 109 yards, Michigan coach Fielding Yost awarded him a game ball. DaPrato rushed for 153 yards and scored 18 (two TD's, three extra points, one field goal) of his nation-leading 124 points against UM that day.

18

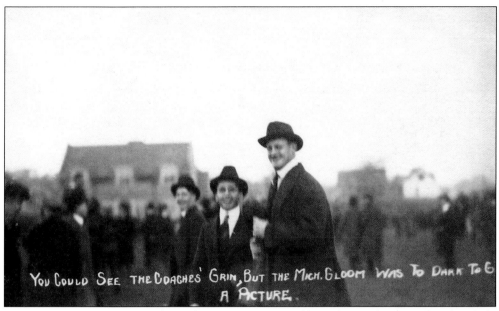

You Could See the Coaches' Grin, But the Mich. Gloom Was To Dark To G A Picture.

NOTHING SATISFIES MORE. Above the caption, "You could see the coaches' grin, but the Mich. gloom was to [sic] dark to get a picture," MAC coach John Macklin flashes a smile not unlike those displayed by every Michigan State coach, ever since, following a win over Michigan. Macklin resigned after the season, having beaten the Wolverines in two the last three meetings.

THE SLAUGHTER. Michigan State backers began the tradition of getting carried away over a win against Michigan, as this 1915 poster attests, relatively early. And Michigan's long-standing penchant for not accepting defeat at the hands of Michigan State without whining about some injustice was apparently also already in full bloom, based a story that appeared in *The M.A.C. Record*: "The outcome was exceedingly pleasing to Aggie enthusiasts for it established beyond the peradventure of a doubt the superiority of the M.A.C. gridders, and Michigan can bring forth no alibi. And the nice thing about this is, that to our knowledge, followers of the Maize and Blue are not trying to dig out excuses. There ain't none such."

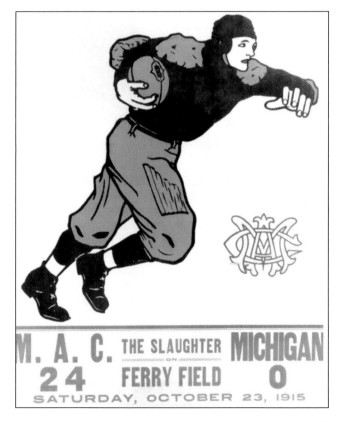

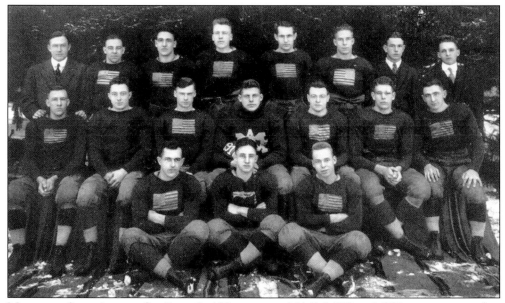

MICHIGAN STATE'S ONLY OH-FERS. In 107 seasons, a MAC, MSC, or MSU team went winless only once. The 1917 team, which wore American flags on their sweaters in honor of teammates and fellow Americans fighting in WW I, lost all nine games by a combined score of 179-23. The Aggies were shutout five times, but there was a legitimate excuse. All of MAC's veteran players were either in Army training camps, in the Navy, or fighting in France.

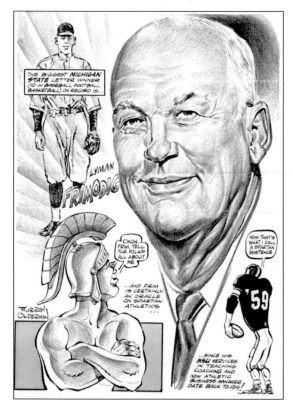

DIGGIN' IT. No other Michigan State athlete has ever won as many varsity letters as Lyman Frimodig's 10 in football, baseball and basketball from 1914 to 1917. A native of Laurium, in Michigan's Upper Peninsula, Frimodig grew up a block away from Notre Dame immortal George Gipp and even made an unsuccessful effort to get his boyhood pal to join him at MAC. After graduating in 1917, Frimodig became a high school principal and then served in the Army. He returned to East Lansing to coach the 1919 freshman football team, and then spent 41 years at the school as an assistant athletic director and business manager.

Two

From Rockne to Crowley to Rockne

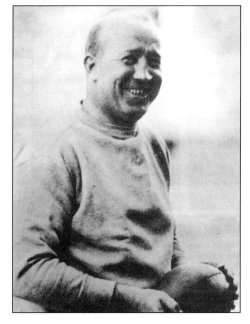

OH, WHAT MIGHT HAVE BEEN. After following 14 consecutive winning seasons with a dismal 0-9 record in 1917, MAC offered the nation's best-known assistant coach, a Notre Dame aide by the name of Knute Rockne, the job of rebuilding the sagging Aggie program. However, before MAC could get Rockne on board, Irish head coach Jesse Harper resigned suddenly. The rest is history.

The formative years for MAC began in 1918 and lasted until 1946. This was a time when the program, as an independent, began to grow up. The school tapped head coaches from rivals Michigan and Notre Dame in the hopes that some of the Wolverine and Irish success would rub off on the Aggies. Although it sleepwalked through the Roaring Twenties, MAC gave fans something to cheer about during the Great Depression. Michigan Agricultural College became Michigan State College in 1925 and the following year got a new nickname. *Lansing State Journal* Sports editor George S. Aldterton pulled the "Spartans" out of a pile of rejects because he considered the school's contest-winning entry, "The Michigan Staters," too cumbersome for newspaper use. The school also began to express its individuality and grasp onto symbols such as the block "S." The team played in a new, bigger facility located where Spartan Stadium now stands, and Michigan State began making significant strides in national prominence.

What helped Michigan State evolve into a respected football power as much as anything was its relationship with Notre Dame. The willingness of Notre Dame to schedule the Spartans on a regular basis indicated to the rest of the nation that there must be something right with the upstart in East Lansing. Michigan State, in turn, tapped into the Fighting Irish's winning tradition by hiring head coaches with ties to South Bend. Jim Crowley, who became famous as one of Notre Dame's famed Four Horsemen, reversed MSC's losing ways by instilling a winning attitude. And Charlie Bachman, Rockne's former Irish teammate, raised the Spartans to new heights. He had MSC running its version of the renowned Notre Dame shift right from the beginning, leading MSC to its first sustained national prominence as well as its first postseason bowl game. Bachman had only one losing season and was the first coach to lead MSC to back-to-back wins over Michigan. His successes set the table for legendary Biggie Munn to move MSC into a new era and admission to the Big Ten Conference.

FOOTNOTE IN FOOTBALL HISTORY. George E. Gauthier (back row, far right) was the first former MAC player hired to be the school's head football coach. Gauthier got the job in 1918 on an interim basis because Chester Brewer was called up for active duty during WW I, along with all but four letter-winners from the 1917 team. Gauthier coached the Aggies for just one season, which is memorable for the mere fact that they handed former MAC job candidate Knute Rockne his first loss as head coach of Notre Dame. The Aggies defeated the heavily favored Irish, which featured George Gipp and Curly Lambeau in the backfield, 13-7. On the Monday before the game, Germany surrendered, and on that Saturday, MAC pulled off what is still considered one of the greatest victories in school history.

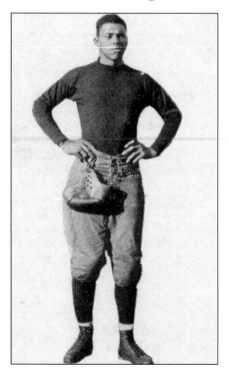

TANK DEMONSTRATION. Although the temperature was unseasonably warm in East Lansing on November 16, 1918, an unyielding rain caused the cancellation of all campus extracurricular activities—including a bayonet drill the ROTC had planned for halftime of that day's football game—except for the MAC-Notre Dame game itself. The Aggies took control on the opening possession with a punishing ground attack, featuring the "tank" methods of fullback Harry Graves, in what became known as "The Battle of the Mud." But it was a 20-yard touchdown pass from Graves, among the first documented by an African-American Aggie player, to end Ed Young that gave MAC a 6-0 lead. The Aggies came back from a 7-6 halftime deficit to win, 13-7.

109-0! The 1920 MAC team, led by rugged fullback John Hammes, took out its frustrations from losing to Michigan, 35-0, by beating Olivet College by 109 points, the biggest output in school history. Hammes also played guard on the Aggie basketball team and was a second-team All-Western first baseman for Aggie baseball.

MAC DID WHAT? In 1921, MAC again failed to persuade Knute Rockne to leave Notre Dame, and settled on former assistant Albert M. Barron to replace George "Potsy" Clark, who went on to coach the Detroit Lions to their first NFL title in 1935. In 1923, MAC did what would be almost unthinkable today when it hired former University of Michigan football player Ralph Young (far left) to be its head football coach and athletic director. The affable Young was one of the few ever to play for storied coaches Amos Alonzo Stagg and Fielding Yost. He played for Stagg at the University of Chicago in 1909–1910, and then at Washington and Jefferson from 1912 to 14. While training with the Signal Corps at Michigan in 1918, Young lined up at tackle for one season under Yost. "The Round Man," as Young was affectionately known, coached MAC to just one winning record—5-3 in 1924. He enjoyed his most success as the school's track coach from 1924 to 1940. One of the most revered figures in Michigan State history, Young served as A.D. until 1954, laying much of the groundwork for Michigan State's admission into the Big Ten.

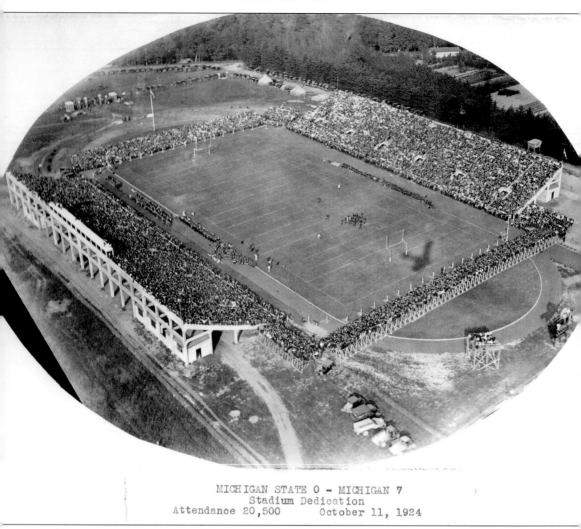

MICHIGAN STATE 0 - MICHIGAN 7
Stadium Dedication
Attendance 20,500 October 11, 1924

STADIUM DEDICATION. In 1923, the Aggies moved from old College Field to the location now occupied by 72,027-seat Spartan Stadium. The first version was built at a cost of $160,000 and had a capacity of 13,064, which could be increased to 20,000 with portable bleachers behind each end zone. Displaying the signature "windowpane" superstructure still evident today, the expanded MAC stadium drew a crowd of 20,500 for the dedication game played against Michigan, which on October 11, 1924 made its first appearance in East Lansing in ten years. The stadium didn't have an official name, but was referred to in game programs as "College Field."

MSC UNVEILED. Changing the name from Michigan Agricultural College to Michigan State College in 1925 didn't do much for the Aggies' football fortunes. After opening the season with a 16-0 victory over Adrian College, MSC finished the season with a 3-5 record. One of the few stars was sophomore Paul Smith, who provided the decisive three points on this 48-yard field goal in a 15-13 win over Centre College of Kentucky.

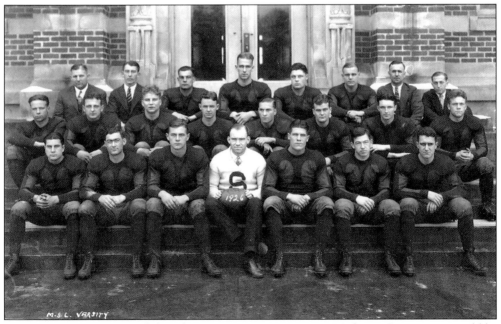

THE FIRST SPARTANS. Had the administration gotten its way, Michigan State teams would be known as the Michigan Staters today. Fortunately, newspapermen objected and MSC became known as the Spartans in 1926. The first "Spartan" captain was Martin Rummel (front row, holding ball). The first "Spartan" football team ended the season with a 3-4-1 record.

CALLING U OF M, AGAIN. After Ralph Young stepped down as the MSC coach, in 1928, he appointed Harry Kipke to replace him. Kipke was one of the University of Michigan's greatest all-time players. Despite his pedigree, Kipke's hiring was hailed in the MSC yearbook "as a brilliant move in the expansion of the college athletically." Kipke started off in grand style with a 103-0 trouncing of Kalamazoo College. Unfortunately, the Spartans' hard-fought 3-0 loss to a vastly superior Michigan team got Kipke noticed by UM brass. After guiding MSC to a 3-4-1 record, Kipke left after one season for Ann Arbor where he coached his alma mater to a 46-26-4 record from 1929 to 1937. He was fired after coaching Michigan to records of 1-7, 4-4, 1-7, and 4-4 from 1934 to 1937. Fritz Crisler replaced Kipke, who became a Coca-Cola executive in Chicago.

THE HORSEMAN COMETH. MSC athletic director Ralph Young saved face over the Kipke fiasco not by finally getting Rockne to come to East Lansing, but by hiring one of his Fighting Irish protégés, Jim Crowley, to coach the Spartans in 1929. Immortalized as one of Notre Dame's fabled Four Horsemen—(left to right) Don Miller, Elmer Layden, Crowley, and Harry Stuhldreher—Crowley played on Rockne's 1924 national championship team. The hiring of Crowley was the beginning of MSC's rise to national prominence.

NATIONAL ATTENTION. Led by All-American quarterback Roger Grove, the Spartans earned national attention in 1930 with the team's most successful season in 15 years. Grove was considered one of the top punters in the Midwest, averaging more than 40 yards in a scoreless tie that broke a 14-game losing streak to the Wolverines. Grove played his best game in the 14-7 victory over powerful Colgate, returning a fumble 36 yards for a touchdown in the third quarter and intercepting a pass in the fourth. The Spartans' only defeat was a 14-13 loss against Georgetown at Washington, D.C. in the first night game in MSC history. Grove also earned All-America honors as a basketball player.

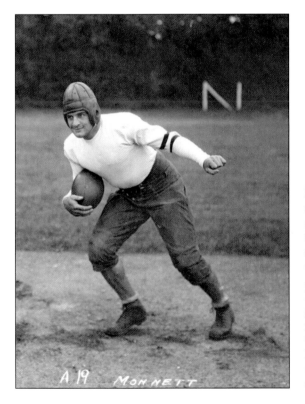

MONUMENTAL BRUSH. The Spartans distinguished themselves in 1930 with a 14-7 Homecoming victory over Colgate, the recognized "defending champions of the East." With under two minutes remaining, a flashy, 5-foot-9 sophomore halfback name Bobby Monnett broke open for the game-winning 62-yard touchdown run in MSC's biggest win in a dozen years. A week later, Monnett led MSC to a 45-0 victory over previously undefeated Case with scoring runs of 41 and 55 yards.

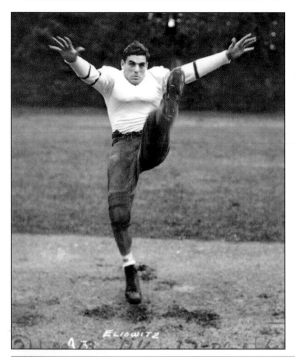

STRONG LEG. In an era when the punter was considered one of football's most glamorous positions, and a vital weapon, MSC's Abe Eliowitz was one of the best. Games often hinged on punting duels. In the 1931 0-0 tie with Michigan, Eliowitz out-kicked Jack Heston, who was considered the greatest punter the game had ever seen. The versatile Eliowitz also was a bruising fullback, signal-caller, ball-carrier, and ultimately the team MVP.

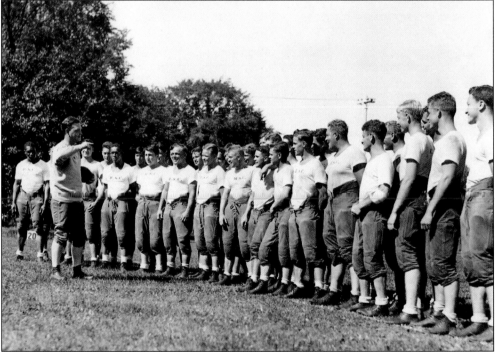

SEASON OF PROMISE. Thirty-five players reported for the first day of MSC practice in 1932 and promptly got an earful from coach Jim Crowley, who told the Spartans what he expected in no uncertain terms. As it turned out, it was Crowley's final season at MSC. The following year he was at Fordham University, where he was the architect of the "The Seven Blocks of Granite" which included a player by the name of Vince Lombardi.

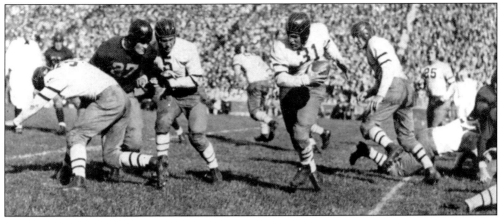

A GREAT START. Spartan guard Bob Terlaak (No. 5) blocks for quarterback Joe Kowatch (No. 31) in the 1932 season opener against Alma College. Michigan State won the game, 93-0, but lost the following week to Michigan, 26-0.

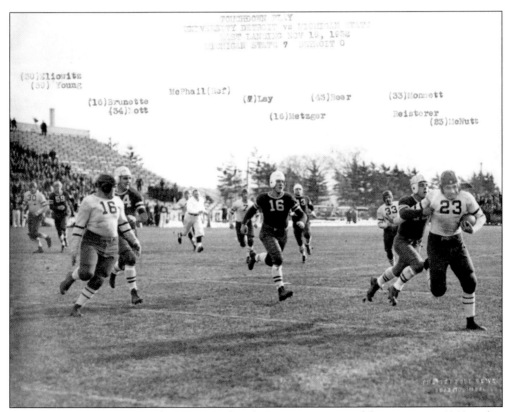

ONE TOUGH MCNUTT. Michigan State closed out its most successful season since 1913 with a 7-0 victory over the University of Detroit. The U of D hadn't lost to the Spartans in five previous meetings, but on November 19, 1932, junior Spartan fullback and captain-elect Bernard McNutt (No. 23) scored the game's only points on this 34-yard touchdown run in the first quarter.

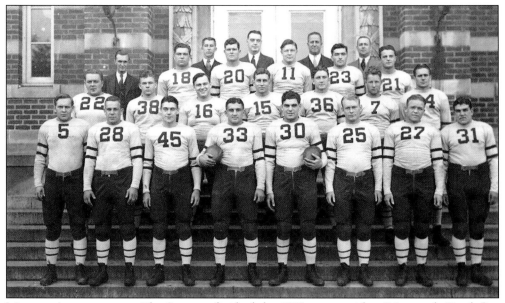

MISSION ACCOMPLISHED. The Spartans finished the 1932 season with a 7-1 record. Coach Jim Crowley resigned after five winning seasons and bringing prominence to a program that had registered just one winning record in the ten campaigns prior to his arrival. Ironically, it was MSC's 18-13 upset of Fordham that prompted that school to lure Crowley away from the Spartans, much like Michigan did with Harry Kipke, Crowley's predecessor at MSC. Halfback Bobby Monnett (No. 33) was the Midwest's leading scorer with 80 points on 10 touchdowns and 20 extra points.

CALLING NOTRE DAME, AGAIN. To replace Jim Crowley in 1933, MSC once again turned to Notre Dame. But once again, the school didn't get its candidate of choice, Knute Rockne. Instead, it acquired one of Rockne's former Irish teammates, Charlie Bachman, who was previously the head coach at Northwestern, Kansas State, and Florida.

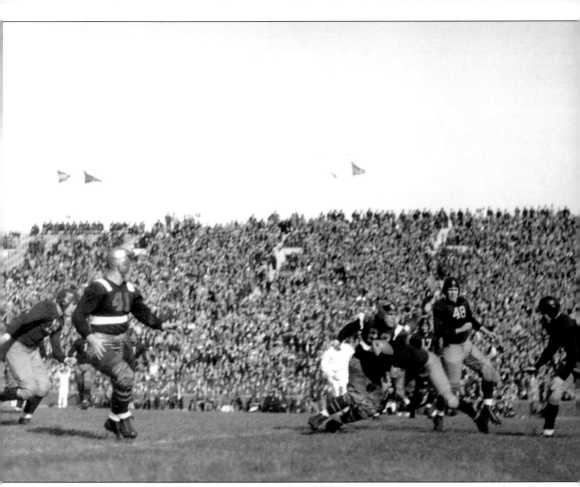

WHAT ELSE MIGHT HAVE BEEN? Take a close look at the October 6, 1934 game between MSC and Michigan in Ann Arbor. Can you tell which team is which? Not by looking at the helmets. *That's MSC wearing the winged helmets* and the Wolverines in the solid-black headgear. Michigan State was one of the first of numerous teams to adopt the winged emblem. Coach Charlie Bachman also departed from the school colors by outfitting the Spartans with new black and gold uniforms. Michigan didn't don its so-called "unique" winged helmet, which has become a college football icon, until 1938. How might the paths of the two programs changed had Michigan State retained the winged look? That's Spartan end and team MVP Ed Klewicki getting tackled during a 25-yard reception in MSC's 16-0 victory.

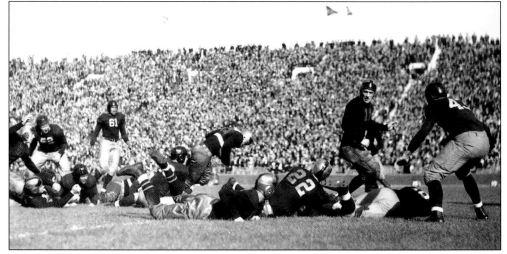

"Somebody Said it Couldn't be Done." Second-year MSC coach Charlie Bachman used that line from a popular composition to set the tone for accomplishing what many in the Midwest believed to be the impossible—beat mighty Michigan. When he arrived from Florida in the spring of '33, Bachman said UM should be regarded as just another team and that all the pointing toward Michigan spoiled the Spartans for the other games on the schedule. The strategy worked. In '33, MSC scored its first touchdown on UM since 1918. A year later, runs like this one by halfback James McCrary helped MSC beat Michigan, 16-0. It was the Spartans' first victory over the Wolverines in 19 years, and the first of four in a row.

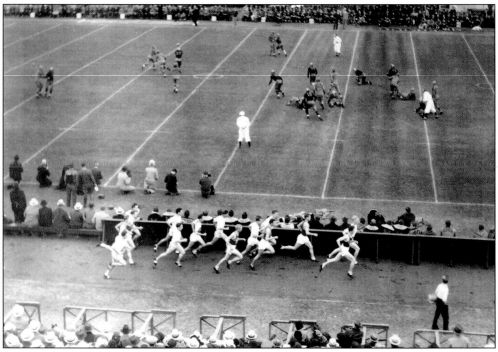

It Really Was a Track Meet. While Michigan State was improving its record to 5-0 with a 13-7 victory over Marquette in 1934, a cross-country race started and finished in the MSC stadium during the game.

CLOSING IT OUT. Michigan State won its final three games to finish with an 8-1 record in 1934. Spartans departed Lansing by train for their final game, against Texas A&M, on Wednesday, December 5. The itinerary issued to each player warned: "This trip will take six days, so be sure you have books and class work along with you." And for after the game: "The evening is your own. Remember, however, although the season is over you are still representing Michigan State College." The team arrived in San Antonio, Texas on Friday, December 7, and on Saturday the Spartans defeated the Aggies, 26-13, with the aid of a touchdown-producing Statue of Liberty play in which quarterback Dick Colina grabbed the ball off halfback Kurt Warmbeim's cocked throwing hand.

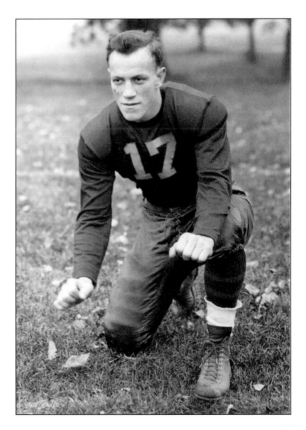

BREAKTHROUGH SEASON. Michigan State achieved many firsts in 1935. Sid Wagner (No. 17), a 5-foot-11, 186-pound guard, earned the school's first major All-America recognition from United Press, International News Service, the *New York Sun* and *Liberty Magazine*. MSC defeated Michigan 25-6, marking the first time the Spartans had won two in a row over the Wolverines. The school finally named its stadium in honor of former coach John Macklin and Macklin Field was dedicated on November 9, 1935 in the game against Marquette, which won, 13-7. The team traveled to the West Coast for the first time, defeating Loyola of California, 27-0, in the season finale, and finished with a 6-2 record.

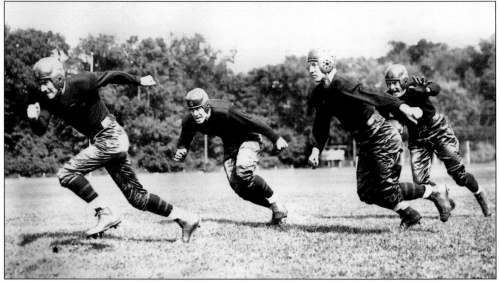

MIGHTY MITES. Considered one of the nation's lightest teams in '35, the Spartans quickly became known as "the Mighty Mites of Michigan State." The backfield of (left to right) quarterback Dick Colina, fullback Art Brandstatter—who made All-America the following season and became a distinguished alum—and halfbacks Steve Sebo and Kurt Warmbein was quick and powerful.

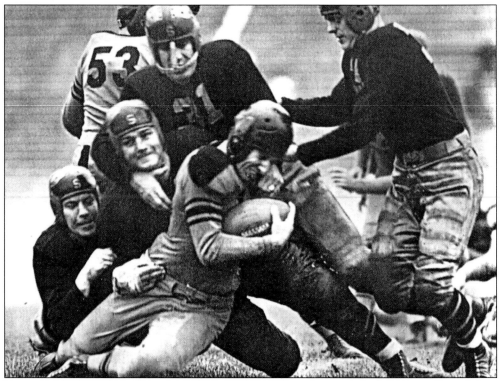

BRAWLERS. By 1936, Michigan State had established an enduring trademark. Regardless of their record, the Spartans are known for playing tough, hard-nosed football. Here they rearrange the face of a Missouri halfback in a 13-0 Homecoming win.

MAKING THE GRADE. National prestige came Michigan State's way in 1937 for various reasons. First, there was the fourth straight win over Michigan, the first time the Wolverines dropped a quartet to the same team since the turn of the century. Quarterback Eugene Ciolek (No. 28) was the star of the Spartans' 19-14 victory over UM with an 89-yard touchdown run and a 90-yard punt. However, halfback Johnny Pingel's two touchdown passes to end Walter "Ole" Nelson, including the 43-yard game-winner in the fourth quarter, were the difference in the game. The only stain on the regular season record was a 3-0 letdown loss at Manhattan a week after beating the Wolverines, but an invitation to play Auburn in the Orange Bowl—the first postseason game in Michigan State history—made up for that.

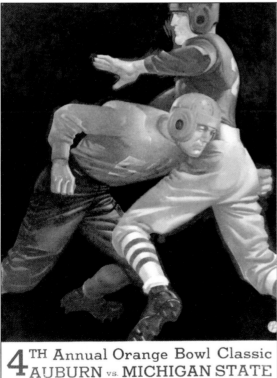

4TH Annual Orange Bowl Classic
AUBURN vs. MICHIGAN STATE
New Year's Day, 1938 PRICE 20¢ Miami, Florida

THE FOURTH ANNUAL ORANGE BOWL. Coach Charlie Bachman's 1937 MSC team was the first in school history to play in a bowl game. The Spartans earned the right to play Auburn on January 1, 1938 in Miami by amassing an 8-1 regular season record that included triumphs over Michigan, Big Six powers Missouri and Kansas, Marquette, and Pop Warner's Temple squad.

35

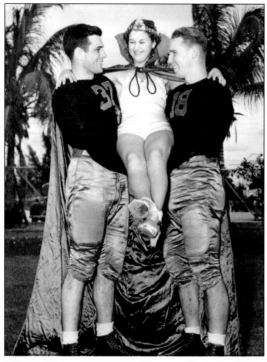

MIAMI MERRIMENT BEFORE THE FALL.
Star halfback John Pingel (No. 37)
and Spartan captain Harry "Fire Chief"
Speelman live it up with the Orange
Bowl queen a few days before facing
Auburn in the Orange Bowl. The
Plainsmen won, 6-0, in large part because
they held Pingel in check. Speelman, a
6-foot-1, 193-pound tackle, won team
MVP honors, "proof that he's a swell guy
as well as an inspiring leader."

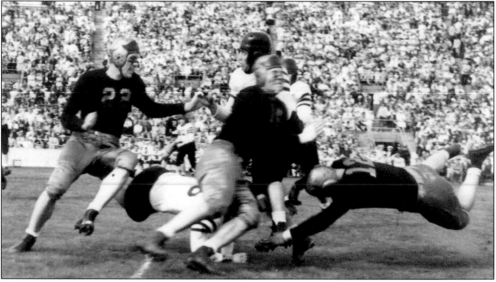

OUTFOXED. Michigan State's Helge Pearson, Norman Olman and Fred Schroeder gang up to stop George Kenmore, a second-string Auburn back, on this play in the third quarter of the Orange Bowl, but they weren't as successful when they needed to be. In the second quarter, Kenmore tossed to Ralph O'Gwynne, also a second-teamer, for a 2-yard touchdown run. "I think we caught them with our shift on the touchdown," O'Gwynne said. Teams of the day would come out in the T-formation before shifting into the box. But Auburn Coach Jack Meagher often ran plays out of the T, having the center snap the ball at the time defenses usually were waiting for the shift to be completed. Nevertheless, the Spartans didn't help their own cause by picking up just two first downs, and getting outgained 312 yards to 57.

THE DUFF. In the fifth game of the 1938 season, Michigan State played its homecoming game against Syracuse, which featured a 5-foot-10, 183-pound junior guard by the name of Hugh Daugherty. The game program described Daugherty in this way: "Home, Barnsboro, Pennsylvania, Graduate of Barnsboro High School. Rugged veteran of last season who depends on plenty of fight and spirit to hold down a starting post against bigger competitors." It didn't mention that Daugherty would go on to become the Spartan head coach in 1954. MSC defeated the Warriors, as Syracuse was then known, 19-12.

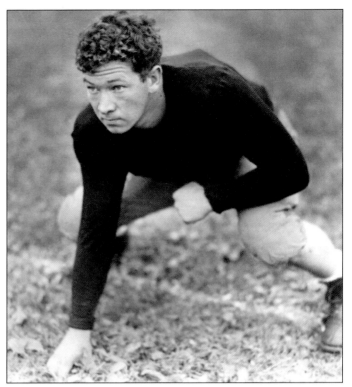

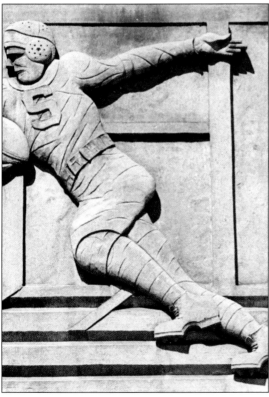

ETCHED IN STONE. Johnny Pingel, a former walk-on punter, figuratively, and literally, etched himself into the stone of Michigan State lore. Pingel averaged 50 minutes a game en route to All-America honors as a senior in 1938. A triple-threat, Pingel was regarded as the Spartans' greatest player in the team's first 50 years. As a senior halfback, Pingel averaged 5.1 yards per carry, completed 55 percent of his passes, and punted a NCAA record 99 times. "When Forest Evashevski coached for Biggie (Munn at MSC), he'd say, 'You must have had a lousy offense to punt that often'," former Michigan State head coach Frank "Muddy" Waters told *Lansing State Journal* columnist Jack Ebling after Pingel's death in 1999. "But when you average 42 yards a kick, you win a lot." A photograph of Pingel served as the model for the life-size relief sandstone sculpture of a football player that's part of a mural adorning MSU's Jenison Field House.

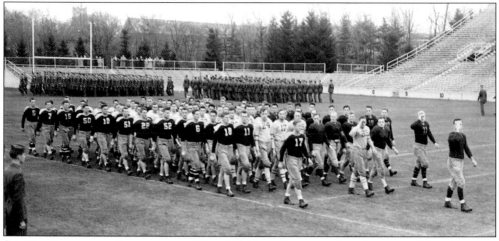

SEASON CALLED ON ACCOUNT OF WAR. Michigan State was forced to cancel its nine-game season in 1943 because 134 of the 135 freshman and varsity players expected to enroll in the fall were called to active duty during WW II. Many of the 3,500 Army trainees sent to MSC's ROTC program competed in a five-team campus league, shown marching at Macklin Field. It is believed Michigan State was the only college that had a campus league for army trainees. Not every school was so affected by the demands of war. Michigan, for example, finished 8-1 and won the Big Ten championship in '43.

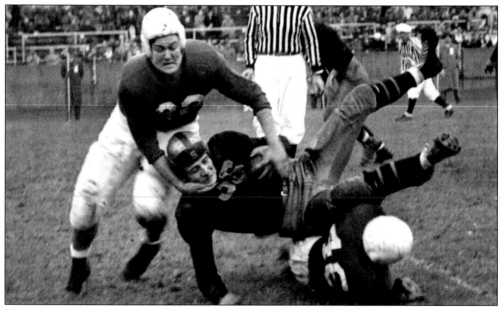

MICHIGAN STATE'S WARTIME FULLBACK STAR. That's how a newspaper report described Spartan fullback Jacweir "Jack" Breslin, the team's MVP as a junior in 1944. The Spartans, led by Breslin (No. 36), pulled off one of the nation's most shocking upsets in 1945 when they defeated Pittsburgh, 12-7. After losing to Michigan, 40-0, in its opener, MSC was listed as a four-touchdown underdog to the Panthers. Breslin, the senior captain shown picking up yardage against Pitt, scored the difference-maker on a 3-yard sweep in the second quarter. "Psychologically we were in a pip of a spot," said Coach Charlie Bachman. "We had everything to win, nothing to lose, and Pitt made the mistake of looking ahead to next week's game with Notre Dame."

READ ALL ABOUT HIM. A former fourth-string walk-on, Russell Reader rescued MSC's flagging fortunes in 1945. He came off the bench to complete 8 of 10 passes and scored the winning touchdown and extra point in a 7-6 win over Kentucky. A week later, Reader's 7-for-9 passing was instrumental in the sensational 12-7 upset of Pitt. Reader finished the season second in the nation in passing to Alabama All-American Harry Gilmer. Reader completed 53 of 90 passes for 617 yards, rushed for 201 yards, caught 4 passes for 95 yards, returned 18 punts for 189 yards, 10 kickoffs for 167, and scored 5 touchdowns and 6 extra points.

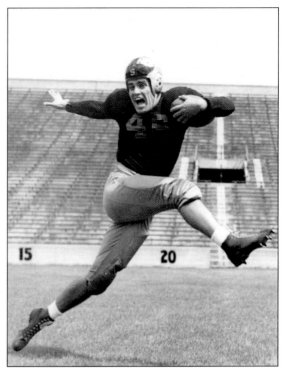

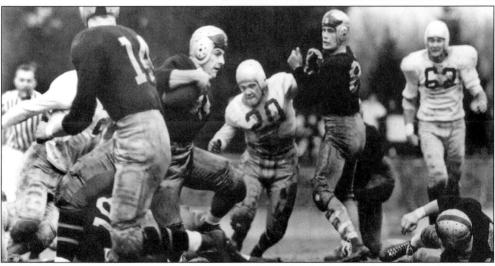

LITTLE BIG MAN. The 1946 season was going down the drain after the Spartans lost for the fifth time in six games, 55-7, to Michigan. But then George Guerre, a 5-foot-5, 155-pound sophomore dynamo, kicked it into gear. Guerre and fellow Flint (Michigan) Central High School grad Lyn Chandnois were dominant in the final three games of the season, all wins. Guerre rushed for 180 yards, including 59 on a touchdown run against Marquette. Against Maryland, Guerre ran for a 3-yard touchdown and threw a 30-yard touchdown pass to Chandnois, who also ran for a 4-yard score. And in the finale against Washington State (shown here), Guerre's 19-yard scoring gallop, followed by Chandnois' 35-yard touchdown run with seven minutes remaining, provided the decisive margin in a 26-20 win. Guerre ranked 13th in the nation in total yardage with 1,029.

MR. MSU. As a triple-threat, no Spartan can rival Jack Breslin. He was a bruising rusher, an effective passer, and dangerous punter who was regarded as the nation's best at the quick kick in 1945. Breslin also lettered in basketball and baseball, batting a team-best .338 in '46. Breslin continued to build on his legend at Michigan State as an administrator, lobbyist and visionary. He had oversight of the athletic department, lobbied the state legislature on behalf of the university while being largely responsible for an increase of $130 million in state appropriations. He was instrumental in the addition of 60 campus buildings, including the new basketball arena bearing his name. Breslin's three sons were Spartan athletes. Jay and John (pictured in shoulder pads) played football and Brian played basketball. Breslin died of cancer at the age of 68 in 1988, one year before the opening of the Jack Breslin Student Events Center, a $40 million all-events facility

THREE

The Next Big Thing

RISING TO THE TOP. Michigan State football began its ascent to the stratosphere on December 14, 1946, the day it named 38-year-old Clarence "Biggie" Munn, a former University of Minnesota All-Everything, as its new head coach. Munn moved to MSC from Syracuse, where he served as head coach in 1946. He signed a contract that reportedly paid him $10,000 a year to coach the Spartans, and he turned out to be a bargain at any price. He led MSC to its first national championship in 1952, and the following season its first Big Ten title, Rose Bowl appearance and postseason victory.

Biggie Munn wasn't politically correct long before anybody had ever heard the term. Six months after being named MSC's new head coach and three months before his first game as a Spartan, Munn gave the Lansing Kiwanis Club a glimpse at his refreshingly no-holds-barred style. Departing from his prepared text, Munn made headlines by ripping Big Nine conference schools for rejecting Michigan State's application to join the conference. Munn accused member institutions of surreptitiously giving cash to football players. Upset with one Big Nine official's assertion that MSC didn't belong in the Big Nine because it would prove to be a "weak sister," Munn claimed the league, which didn't allow athletic scholarships at the time, objected to MSC's practice of openly providing athletes with financial aid. "They dislike our Jenison scholarships," Munn said without naming names. "But why should we have to do like of a lot of them do—hand it under the table? Then, they take them [the players] into the next room

and make them sign a paper to the effect that they haven't received anything." University of Michigan faculty representative Ralph Aiger responded to Munn's comments by saying that "sort of statement by a Michigan State College representative is the surest way of closing the Big Nine door to MSC." Munn's statements weren't as damaging as originally feared. The Big Nine approved MSC's application less than two years later.

Michigan State first began posturing for a spot in the Western Conference in the 1920s, and stepped up its advances after the University of Chicago dropped football after the '38 season. Michigan State president John Hannah, seeing sports, especially football, as a way to enhance the college's national image while coalescing students, faculty, alums and donors, formally applied for application after Chicago withdrew completely from the conference in 1946. MSC's admission to the newly named Big Ten was officially ratified on May 20, 1949, but the Spartans did not begin competing for the conference football championship until 1953.

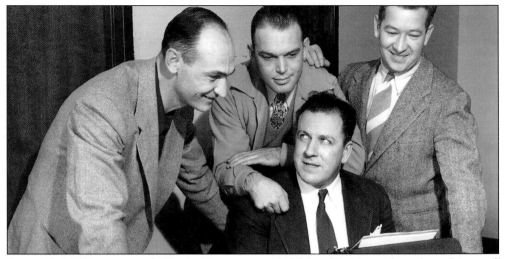

SUPER STAFF. Spartan coach Biggie Munn surrounded himself with a talented coaching staff that included (left to right) Kip Taylor (ends), Forest Evashevski (backfield), who later became the head coach at Iowa, and his eventual successor, Hugh "Duffy" Daugherty (line). Munn was a former Minneapolis high school sprint champion. His legend began to grow at the University of Minnesota where he played football under Fritz Crisler and was the Big Ten MVP, the nation's outstanding lineman, and a consensus All-American guard in 1931. Munn began coaching as a Minnesota assistant from 1932 to 1934. He was the head coach at Albright College in 1935 and '36 and the line coach at Syracuse in '37. Munn rejoined Crisler at Michigan and was the Wolverine line coach from 1938 to 1945. He then became the head coach at Syracuse where he was reunited with Daugherty for one season, and the two ushered in the Big Ten era at Michigan State together. Munn told his players that the difference between being good and great is a little "extra effort," three-time Spartan captain Robert "Buck" McCurry said.

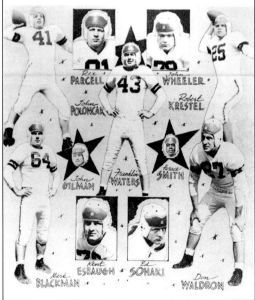

STAR POWER. Coach Biggie Munn's first Michigan State team came out in newly designed green and white uniforms, which mirrored the school colors and replaced the black and gold the Spartans wore under Charlie Bachman. A sophomore fullback named Franklin Waters (No. 43) got a new nickname from backfield coach Johnny Pingel. "I had a good day in the mud against Santa Clara," Waters recalled. "I had 31 carries, which stood as a school record for more than 20 years, for more than 100 yards." "Muddy" Waters went on to become a hugely successful head football coach at Hillsdale (Michigan) College and Saginaw Valley State College before taking over as Spartan head coach from 1980 to 1982.

FALSE START. Spartan lineman Pete Fusi and an unidentified teammate stuff a Michigan Wolverine on this play, but the Biggie Munn era at Michigan State began in 1947 with a 55-0 loss to UM, nonetheless. It was MSC's most lopsided loss to Michigan since falling 63-0 in 1922. A *Detroit Free Press* headline blared: "70,115 Sit In on a Grid Massacre."

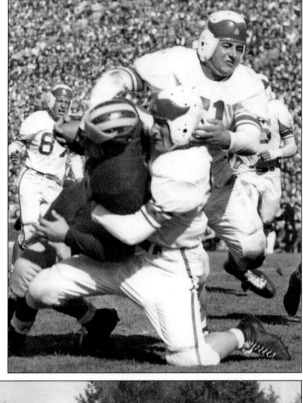

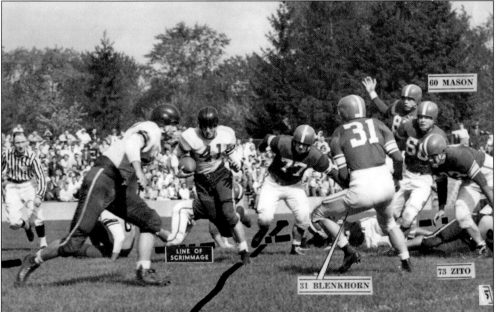

FAST HEALERS. A week after getting crushed by Michigan, future All-American guard Don Mason (No. 60), tackle Jim Zito (No. 73), halfback James Blenkhorn (No. 31) and center Pete Fusi (No. 77), led the Spartans—wearing new-fangled plastic green and white helmets—to one of the nation's biggest upsets in 1947 with this 7-0 victory over Mississippi State. The Spartans fell only to Kentucky the rest of the season and finished 7-2 after beating Hawaii, 58-19, in Honolulu.

THE BUILD-UP. Michigan State upped the ante in the arms race by expanding Macklin Field Stadium's capacity from 26,000 to 51,000 at a cost of $1.5 million in 1948. Only Big Nine conference rivals Michigan, Ohio State, Illinois and Minnesota had comparable football venues. The revamped stadium played a significant role in MSC's ongoing attempts to join the Big Nine because it assured visiting teams larger share of the gate. Furthermore, Michigan State's athletic complex was ballyhooed as one of the nation's finest.

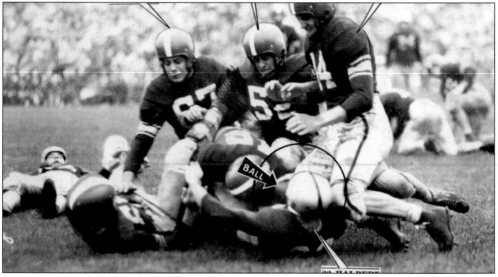

CAPTAIN COURAGEOUS. Robert "Buck" McCurry (No. 52) was a stalwart Spartan center and a punishing linebacker when he was bringing down enemy ballcarriers like Iowa State's Webb Halbert in a 20-0 MSC victory in 1947. McCurry stands alone as Michigan State's only three-time captain, leading the Spartans in '46, '47 and '48. McCurry became a captain of industry as well. After graduating from Michigan State in 1950, he was hired by the Chrysler Corp. and eventually served as the automaker's No. 1 sales executive. After leaving Chrysler in '78, McCurry became a senior vice-president of Toyota USA before retiring in '95. The Spartans went 13-4-2 in McCurry's final two seasons.

ON THE OUTSIDE LOOKING IN. Michigan State's attempts to get into the Big Ten were originally thwarted by stiff opposition primarily from Michigan, which only added more fuel to the already fiery rivalry. "We felt like we had to win to get into the Big Ten," three-time Spartans captain Robert "Buck" McCurry told the Lansing State Journal in 1999. "We knew that it was important for the school to get into the conference in the hopes that people would stop calling us a 'Cow College.' All the guys from that era take a lot of pride in the fact that we helped the school take that important step in its history."

OVER THAT HUMP. Under president John Hannah, Michigan State expanded athletically and academically while moving forward to become one of the nation's leading universities and the 12th largest at the time. Under Hannah, MSC earned a national reputation for being "lusty, ambitious and progressive." Speaking to a student rally outside the campus union on the December 1948 night the Big Nine accepted MSC, Hannah said, "We are a great university. We needed this to put us over the hump in the minds of a few remaining skeptics. Now we are over that hump!"

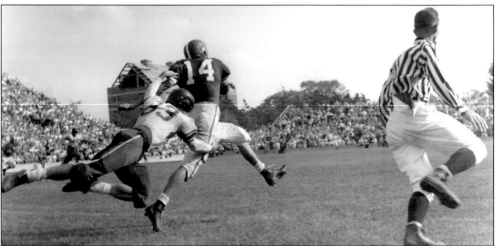

"60 MINUTES." That was just one of Spartan halfback Lynn Chandnois' nicknames. Whatever he was called, the 6-foot-2, 195-pound Chandnois was always impressive. Renowned for his long upfield dashes that left defenders with a view of the No. 14 on his back, Chandnois was named All-American in 1949. While Chandnois was primarily heralded as an offensive halfback, he was so adept on both sides of the ball, the International News Service made him a first-team All-America defensive back along with SMU's Doak Walker. *Colliers* magazine made Chandnois one of its first-team offensive picks because he "is the big, crunching type of runner—invaluable for short yardage when a first down is essential." As a junior in '48, Chandnois set a school record that still stands with 7.48 yards per carry. His 90-yard touchdown run in his final game as a Spartan, a 75-0 rout of Arizona, also holds up as the school standard as does his career record of 20 interceptions. After his college career, Chandnois was the No. 1 pick of the Pittsburgh Steelers where he was earned another nickname, "Money Back."

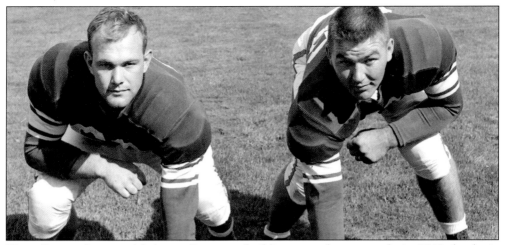

HIGH PRAISE INDEED. Michigan State was building toward a crescendo in 1949 thanks in large part to play of All-America guards Ed Bagdon (right) and Don Mason. Bagdon, whose father was a Lithuanian immigrant, was an innovator who developed an effective brush block technique that allowed him to take one defender out of a play, stay on his feet and go after another and another. Only 5-foot-10 and 200 pounds, Bagdon was deemed the nation's top interior lineman when he was presented with the Outland Trophy, the only Spartan ever to win the award. He started every game from 1946–1949. Bagdon and Mason were members of "Duffy's Toughies," named for offensive line coach Duffy Daugherty, but together formed such a formidable blocking tandem that Michigan coach Fritz Crisler declared: "They are the best pair of guards ever to play in Michigan Stadium."

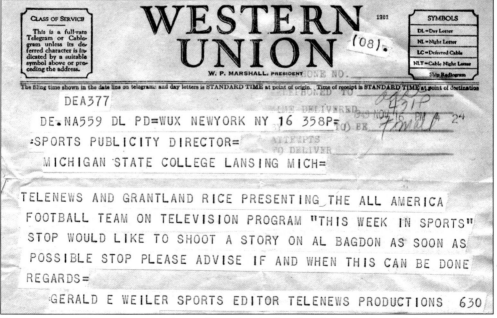

GETTING THE WORD OUT. Michigan State finished with a 6-3 record in '49, but it was clear the Spartans were on the verge of something big. MSC was no longer overlooked and players like All-America guard Ed Bagdon were getting noticed nationally, as this vintage telegram, sent from Telenews Productions to Michigan State's sports publicity office, attests.

THE BEGINNING OF GREATNESS. Led by senior end Dorne Dibble (No. 82), the Spartans came out for the 1950 season opener against Oregon State full of promise, but not necessarily for that season. Of the 66 players on the roster, 30 were sophomores. Dibble was one of two Spartans on the squad to earn All-America honors. Although Dibble caught 15 passes for 362 yards and five touchdowns, he was a *Look* magazine first-team defensive selection. Despite its youth, MSC showed it was already something special with a 38-13 win over the Beavers, and the situation got only better from there.

WEAK SISTERS INDEED. The look on the faces of Michigan coach Bennie Oosterbaan (center) and the No. 1-ranked Wolverines sums up the 1950 meeting between UM and MSC. The two-touchdown-underdog Spartans' 14-7 victory, before a stunned Michigan Stadium crowd of 97,239, was their first over Michigan in 13 years. Michigan was the preseason Big Ten favorite and picked to contend for the national championship.

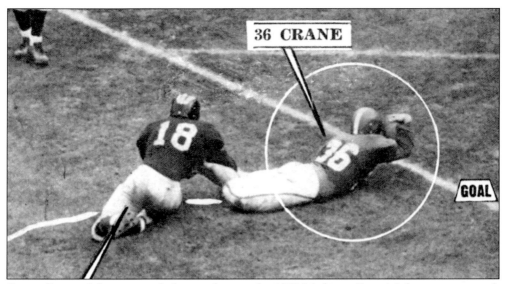

OH SO SWEET. Like so many before, and since, the 1950 Michigan State-Michigan game wasn't without controversy. MSC fullback Leroy Crane scored the winning touchdown on a first-down, 7-yard run with 11 minutes remaining in the final quarter. However, before Crane reached the goal line, Michigan's Leo Koceski hit him at the 2-yard line. A series of eight sequential newspaper photos seem to show Crane's knee touching the ground before the ball reached the end zone. After a consultation, the officials ruled that Crane's momentum carried him to paydirt and awarded the touchdown that may not have counted under today's rules. MSC rose to No. 2 in the Associated Press poll the following week, much to coach Biggie Munn's dismay.

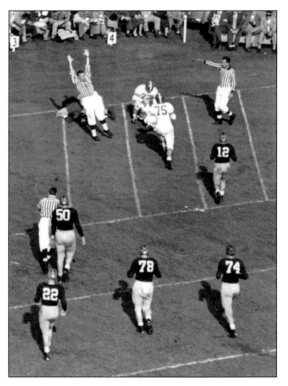

THE WEAVE. The euphoria from beating Michigan and rising to No. 1 in 1950 lasted only until MSC lost its next game, 34-7, to Maryland. It may have been the first time the Spartans were on the losing end of an "upset." But, the Spartans regained momentum with three straight wins including this wild 36-33 victory at Notre Dame. Doug Weaver, an undersized linebacker, set up the Spartans' second touchdown with an interception. Then, after Jim King blocked a punt in the end zone, Weaver recovered for the touchdown that put the Spartans ahead, 20-6, in the first quarter. The victory was MSC's first over Notre Dame since 1918, and it marked the first time the Spartans had swept their chief rivals, Michigan and the Irish, in the same season. After a sterling playing career, Weaver was the head coach at Kansas State, and subsequently served as the Michigan State athletic director from 1980 to 1990.

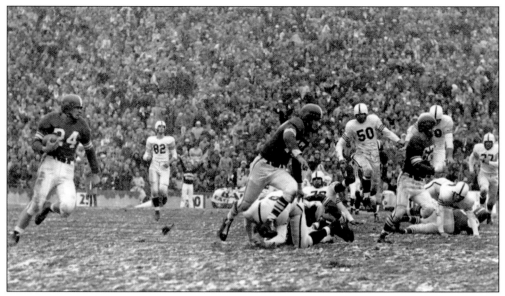

Worth a Grand. Senior halfback Everett "Sonny" Grandelius, shown here scoring one of his three touchdowns in the 1950, 35-0 drubbing of Indiana, earned All-America honors that season after gaining 1,023 yards to become Michigan State's first 1,000-yard rusher, and only the 17th in college football history. Grandelius also scored 12 touchdowns. He was drafted by the New York Giants and led the team in rushing in '53, his only season in the NFL. Grandelius then became the head coach at Colorado, and was the Big Eight coach of the year in '61. The Spartans closed out 1950 by outscoring Indiana, Minnesota, and Pitt by a combined score of 81-0 to finish 8-1.

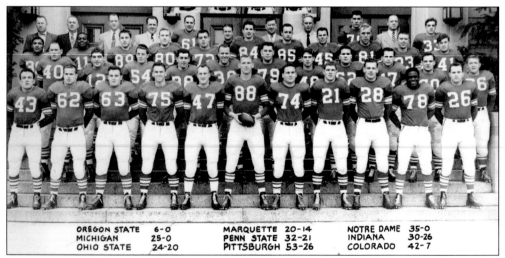

OREGON STATE	6-0	MARQUETTE	20-14	NOTRE DAME	35-0
MICHIGAN	25-0	PENN STATE	32-21	INDIANA	30-26
OHIO STATE	24-20	PITTSBURGH	53-26	COLORADO	42-7

Season of Close Calls. Led by four All-Americans—defensive back James Ellis (No. 11), quarterback Al Dorow (No. 47), end Bob Carey (No. 88), and tackle Don Coleman (No. 78)—the 1951 Spartans averted disaster against Oregon State, Ohio State, Penn State and Marquette to finish undefeated (9-0) and capture their first national championship. Michigan State ranked second to Tennessee in the final Associated Press poll, but was No. 1 according to Helms and Poling. MSC had to decline an invitation to play in the Cotton Bowl because the Big Ten wouldn't bend its rule prohibiting members from playing in any postseason game other than the Rose Bowl, even though the Spartans wouldn't compete in the conference race until 1953.

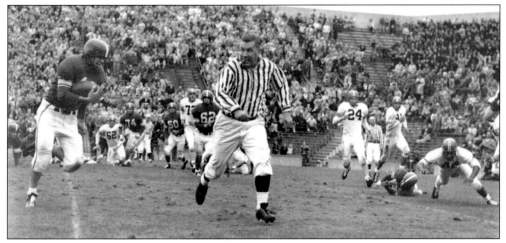

SLOW OUT OF THE GATES. Michigan State's preseason No. 2 ranking nearly ended before it began. The Spartans opened the season with a 6-0 home victory over Oregon State, and that lone score came on the most tenuous of terms on one of the most famed plays in MSU history. On fourth-and-goal-to-go inside the Beaver 1-yard line late in the first half, the pass from center inadvertently hit fullback Dick Panin in the chest and bounced high into the air before being grabbed by quarterback Al Dorow, who had the presence of mind to continue the buck lateral play he called in the huddle. The pitch went to halfback Don McAuliffe, who then swept around right end, cut inside an official and sprinted into the end zone.

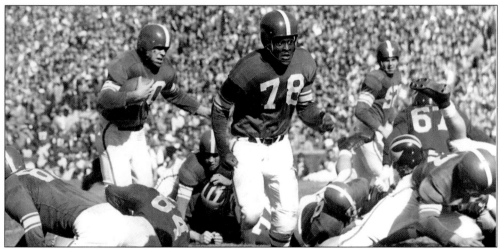

UNANIMOUSLY UN-ANONYMOUS. Offensive linemen are rarely singled out for winning games, but Spartan tackle Don Coleman (No. 78) was in 1951 when he was credited with eight key blocks, including this one for halfback Don McAullife, which paved the way for long-gainers in the 25-0 victory over Michigan in Ann Arbor. Although he stood just 5-foot-10 and weighed in at 185 pounds, Coleman was the Spartan MVP during their perfect 9-0 run to a national title. He also was the school's first unanimous All-American. Coleman finished second in the Outland Trophy voting to Oklahoma's Jim Weatherall. Michigan coach Bennie Oosterbaan claimed Coleman's only rival was Minnesota's Bronko Nagurski. "Pound for pound, the Big Ten has never seen a better tackle than Don Coleman, who was smart, quick as a cat, and a deadly, fearless tackler," Oosterbaan said. Coleman was inducted into the National Football Foundation College Hall of Fame in 1975.

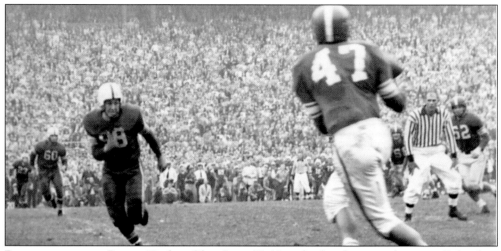

BATTLING OFF THE ROPES. Trailing Ohio State 20-10 as the fourth quarter began in Columbus, Michigan State's outlook for a national championship in '51 was dimming. Trailing by three points with less than two minutes to play, MSC faced fourth down at the OSU 28. Spartan fullback Evan Slonac, in the single-wing formation, took the direct snap from center and faked a plunge into the line before handing off to All-America quarterback Al Dorow (No. 47). Dorow lateraled to sophomore left halfback Tom Yewcic, who was sweeping right with nearly the entire Buckeye defense in pursuit. Meantime, Dorow sneaked out of the backfield and was wide-open at the 11 for Yewcic's first collegiate pass, which traveled 50 yards across the field. Dorow evaded the last two Buckeyes while tight-roping the sideline to score the touchdown that gave MSC a 24-20 come-from-behind win. "One of the greatest games of all times," Spartan coach Biggie Munn said afterward.

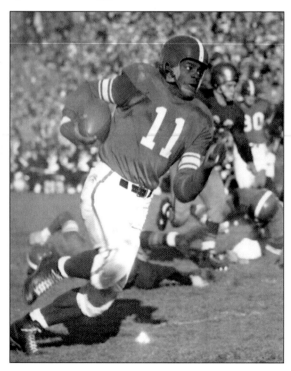

NO. 11, ELLIS. In 1951, speedy sophomore defensive back and returnman James Ellis became the first Spartan underclassman to earn All-America honors. He returned 24 punts for 305 yards, including this 54-yarder against Pitt. A week earlier he ran one back 57 yards against Penn State. He also had a 79-yard kickoff return against Michigan and intercepted six passes, including three against Oregon State. Ellis repeated as an All-American as a junior after returning a punt 59 yards for a touchdown against Syracuse, being credited with seven touchdown-saving tackles, four fumble recoveries and two interceptions.

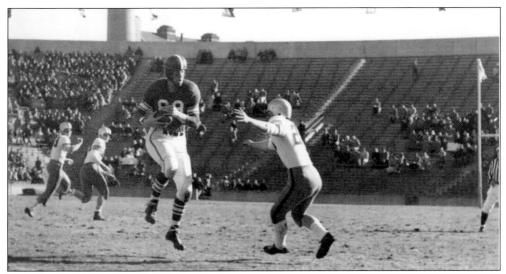

CAREY-ALL. Bob Carey, a towering 6-foot-5, 215-pound senior end (No. 88) completed his college career with All-America honors in 1951 after leading the Spartans in receiving for three straight seasons. In his final game, here against Colorado, Carey caught five passes for 104 yards and two touchdowns in the 45-7 win. He finished his career with 65 receptions for 1,074 yards and 14 scores. A great all-around athlete, Carey also handled the place-kicking for MSC. He played on the Spartan basketball team and was a shot-putter on the track team. He is one of ten Michigan State athletes to earn nine varsity letters.

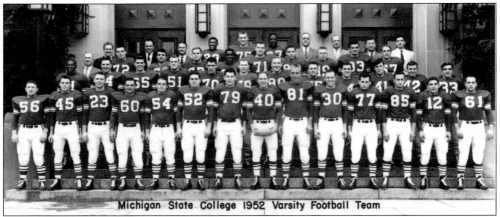

Michigan State College 1952 Varsity Football Team

ALL GROWN UP. The Spartan sophomores of 1950 matured into one of the most formidable college teams of all time in '52. Except for a three-point struggle with Oregon State and a 14-7 wakeup call from Purdue, no opponent came closer than 14 points while undefeated MSC's average winning margin was 25 points. The Spartans, playing their final season as an independent, garnered 32 of 35 first-place votes from UPI's coaches panel, missing a perfect score by just seven points. Michigan State, which ended the season with the nation's longest win streak at 24 games, attracted 207 of a possible 271 first-pace votes for one of the highest scores ever recorded in the Associated Press poll of sportswriters and broadcasters. Sophomore end Ellis Duckett (third row, fifth from left), junior defensive back Jim Ellis (second row, first on left), senior defensive middle guard Frank Kush (No. 60), senior halfback Don McAulliffe (No. 40), senior linebacker Dick Tamburo (No. 52), and junior quarterback Tom Yewcic (second row, No. 41) were All-Americans.

KNOCKOUT PUNCHER. Because of his prematurely balding head, rugged Michigan State halfback Don McAuliffe was known as "Skull." Because of his giddy-up running gait, he was also known as "Hopalong." The *Detroit News* described him as "heavy-legged." Be that as it may, with the Spartans trailing by two touchdowns late in the first quarter of the 1952 opener against Michigan, McAuliffe dodged three defenders at the line and broke free for a career-long 70-yard touchdown run that sparked MSC to 27 unanswered points in a 27-13 win. A team captain, McAulliffe won All-America honors after leading Spartans in rushing with 566 yards for a 4.5-yard-per-carry average, and scoring with 54 points. Nevertheless, coach Biggie Munn said, "Mac is one of the greatest captains I've ever seen. I think he was possibly more important to us as captain than he was as a fine player."

NARROW ESCAPE. It seems every national champ has to be lucky at some point during the season, and after opening with a 27-13 victory over Michigan in Ann Arbor, the No. 1-ranked Spartans' closest call of 1952 came at Oregon State in the season's second game. Eugene Lekenta, a seldom-used fullback who up to that point had kicked only one field goal in a game—while at Grand Rapids (Michigan) Union High School—nailed this 17-yarder as time expired. The Spartans came as close to tying the game as a team can possibly come. Lekenta missed from 22 yards with seven seconds remaining, but the Beavers were flagged for being offside, giving Lekenta another shot with two seconds showing.

YOU SHOULD HAVE SEEN HIM. Senior All-American quarterback Tom Yewcic broke the school record by passing for 941 yards on 41-of-95 accuracy in '52. He also threw for ten touchdowns. But his claim to fame was coming through in the clutch. His first collegiate pass beat Ohio State in '51. The following season he completed 7 of 14 passes for 171 yards in the 27-13 come-from-behind victory over Michigan. Yewcic became only the second Michigan State player to pass for 200 yards in a game when he threw for 202 in the 48-6 pounding of Texas A&M.

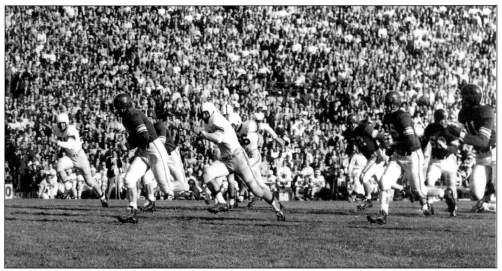

AGGIE-NIZINGLY EASY. After overpowering Texas A&M, 48-6, in East Lansing, Aggies coach Ray George said of the 1952 Spartans, "It rates as one of the finest college football teams I've ever seen, [and] that goes back a good many years, too. I'd say that on a given Saturday when the Spartans were at their peak—like this one—they'd likely beat any team, great ones of the past or present. They have everything a great team needs and they have lots of it. It's not so much the first team that hurts you, it's (their) second and third that crush you." MSC put up the most points on A&M since 1898 and coupled with Princeton's loss to Penn, the Spartans had the nation's longest win streak at 18. MSC used 13 different ball-carriers, who pounded out 283 yards against the Aggies.

FRANK KUSH. The name is spoken reverently at Arizona State, where Frank Kush coached for 22 years until he left in 1979 as the nation's second-winningest active coach with a record of 176-54-1. But before they erected a statue of Kush in front of Sun Devil Stadium, he was a tough-as-bronze All-American defensive middle guard for Michigan State. Kush was renowned for disrupting opponents' offensive plans by wedging his 5-foot-9, 180-pound body into the backfield mechanism just as the play was getting started. In 1975, Kush led Arizona State to a 12-0 record, a victory over Nebraska in the Fiesta Bowl, and the national championship awarded by the *Sporting News*. Kush also coached the Hamilton Tiger Cats of the Canadian Football League in 1982, the NFL Baltimore/Indianapolis Colts from 1983 to 1985, and the USFL Arizona Outlaws in '86. Kush was inducted into the National Football Foundation College Hall of Fame in '95, and the National Polish-American Sports Hall of Fame in '98.

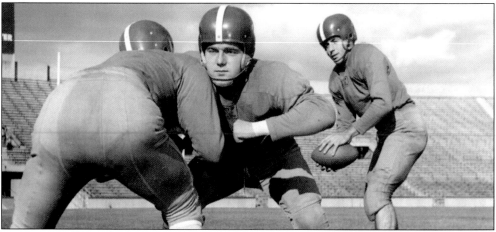

KEY MOVE. Dick Tamburo (center) and Frank Kush began the 1952 season as offensive linemen. But after Oregon State and Michigan both almost upset the Spartans by running through their defense with ease, coach Biggie Munn switched Tamburo to linebacker and Kush to defensive middle guard. In the second-to-last game, Tamburo recovered three Notre Dame fumbles, including one that set up a touchdown, in the 21-3 national championship-clinching victory over the Fighting Irish. Tamburo was named All-American team MVP. He went on to serve as an associate athletic director at Kent State and the University of Illinois in the '70s, an assistant football coach and then athletic director at Arizona State, and then as athletic director at Texas Tech in the '80s. He retired as Missouri's athletic director in 1992.

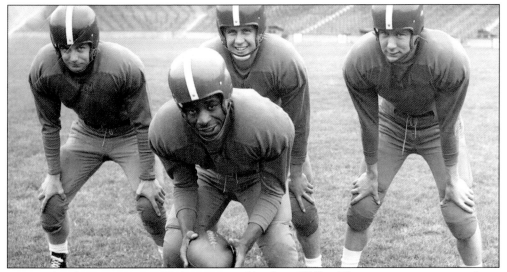

DESTINY'S QUARTERBACK. With a name like his, Willie Thrower was meant to be a quarterback. And in 1952, Thrower, of New Kensington, Pennsylvania, became the Big Ten's first African-American quarterback. While backing up Tom Yewcic, Thrower was considered MSC's most accurate passer and an example of the Spartans' superior depth. In a $2^1/_2$-minute span during the fourth quarter of the 48-6 drubbing of Texas A&M, Thrower threw for 107 yards, on 7-of-9 accuracy, and two touchdowns. Later in the season, he entered the Notre Dame game with the Spartans trailing 3-0 and guided MSC to its first and third touchdowns of the 21-3 victory that all but clinched the national championship. In 1953, Thrower joined the Chicago Bears and became the NFL's first black quarterback. He completed 3 of 8 passes for 27 yards and an interception in a 35-28 loss to San Francisco—his only NFL game. But, Thrower felt he made his mark. "I knew there had never been a black quarterback," Thrower said four years before his death on February 20, 2002 at the age of 71. "I was proud of it. It was a Jackie Robinson-type thing. It was pioneering. It was a step forward."

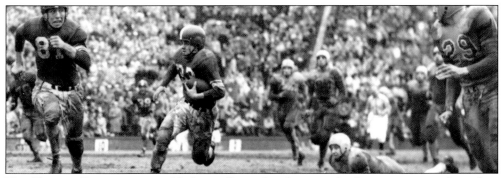

THE END OF INDEPENDENCE. Michigan State closed out its final season as an independent by drubbing Marquette, 62-13. The victory extended the Spartan's nation-leading win streak to 24 games and left no doubt in anyone's mind who the undisputed national champ was. What's more, things were looking bright for the start of Big Ten competition. Of the 454 rushing yards MSC piled up against the Hilltoppers, the backfield set to return in '53 gained 302. Underclassmen also scored all but 12 of the points against the Marquette 11. Fullback Evan Slonac (No. 33), seen here following end Paul Dekker, rushed for 106 yards and a 7-yard touchdown, and also scored on 59-yard screen pass. For the season, Slonac led the team in scoring with 60 points on ten touchdowns.

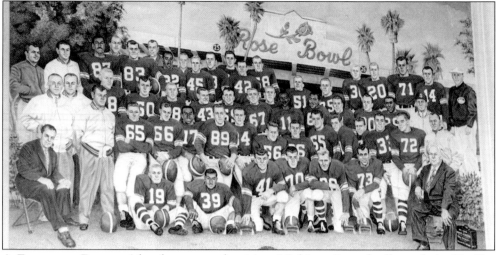

A FRAGRANT DEBUT. After four years of waiting, Michigan State finally made its Big Ten football debut in 1953, and the best of its first opportunity in conference play. Led by All-Americans LeRoy Bolden (No. 39), Larry Fowler (No. 70) and Don Dohoney (right of Fowler), the Spartans lost only once, to Purdue, all season and tied with Illinois for the Big Ten championship. Michigan State was selected to represent the Big Ten in the Rose Bowl and the Spartans prevailed over UCLA, 28-20, in their first visit to Pasadena.

THE FOUR PONYMEN. Striking a pose like the one made famous by Notre Dame's Four Horsemen, Michigan State's famed Pony Backfield—(left to right) right halfback Billy Wells, fullback Evan Slonac, left halfback LeRoy Bolden, and quarterback Tom Yewcic—were small (averaging 172 pounds each) and quick. In 1951, coach Biggie Munn used the frisky Pony Backs to deliver a knockout punch to opponents. They carried MSC to a championship in 1953. Wells scored the Spartans' first touchdown in Big Ten play on a 3-yard run with 8:40 remaining in the first quarter of the season opener at Iowa. The first passing touchdown came from Yewcic to Wells for 43 yards with 10:28 remaining in the game. MSC began galloping to the title with a 21-7 victory over the Hawkeyes.

DOIN' IT RIGHT. Senior end and captain Don Dohoney led a Spartan defensive charge that held five of nine regular-season opponents to under 10 points. A consensus All-American, Dohoney attracted national attention after getting much of the credit for holding Minnesota's great All-American, Paul Giel, to a career-low 23 yards on 20 rushes in a 21-0 MSC victory. "It was my greatest thrill," MSC coach and Minneapolis native Biggie Munn said after vanquishing his alma mater. "The greatest. It was really wonderful to win this one on own my home grounds."

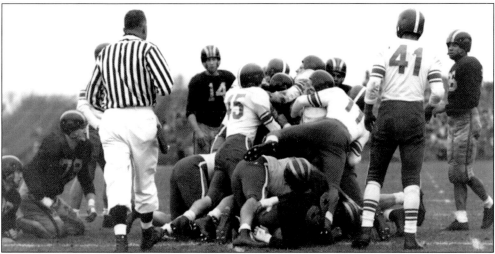

SPOILED! After defeating Iowa, Minnesota, Texas Christian, and Indiana, Michigan State's nation-leading win streak grew to 28 games heading into Purdue. The previously winless "Spoilermakers" intercepted five Spartan passes, but managed only one touchdown in the 6-0 win. Second-string Purdue fullback Danny Pobojewski scored on this play early in the fourth quarter by plowing over from the 1-yard line on the third play of the fourth quarter despite the best efforts of Spartan defenders Don Dohoney, Gerald Planutus (No. 45), and James Ellis (No. 11). Ironically, Pobojewski, of Grand Rapids, Michigan transferred to Purdue after failing to make the Spartan team in 1947. It was the No. 2-ranked Spartans' first loss since falling to Maryland in the third game of the 1950 season, and first shutout since losing to Michigan, 55-0, in the 1947 season opener.

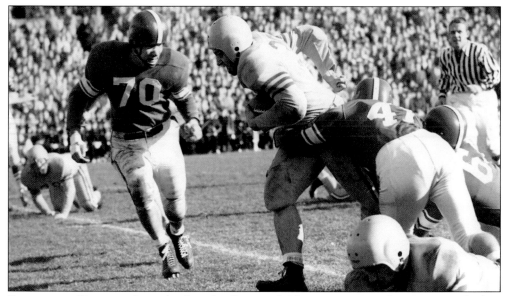

FOLLOWING FOWLER. A week after the Spartans' 28-game win streak was snapped, they started a new one by mowing down Oregon State, 34-6. Senior tackle Larry Fowler led the way against the Beavers. Michigan State held a 283-68 advantage in rushing and 311-106 in total yardage. Fowler went on to earn All-America honors.

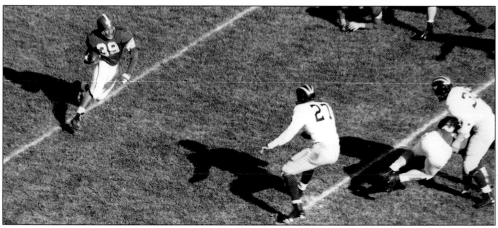

EMBOLDENDED. When LeRoy Bolden was a junior at Flint (Michigan) Northern High School, his notorious temper got the best of him when he responded angrily to being roughed up during a scrimmage. After kicking Bolden out of the game, Northern coach Guy Houston told Bolden, "I don't know if you can make the grade because there's no room on the squad for hotheads. I think it would be better for all concerned if you dropped football," not the least of whom would someday be Ohio State coach Woody Hayes. But Bolden responded by saying "It won't ever happened again." And it didn't, as Bolden, shown here against Michigan in '53, comported himself with class throughout his career as a 5-foot-7, 163-pound scatback. A year after setting up the two decisive touchdowns against the Buckeyes, the gracefully elusive and remarkably powerful All-American personally destroyed 16th-ranked Ohio State with 128 yards and scoring runs of 4, 37, and 20 yards. "That's twice he's done it," Hayes said after the Spartans knocked the Buckeyes out of the Big Ten championship race.

SMELLING ROSES. Wisconsin's 34-7 upset of previously unbeaten Illinois and MSC's 14-7 win over Michigan forged a tie for the Big Ten championship and a conundrum for conference athletic directors whose vote would decide which team to send to the Rose Bowl. After a telegraphic ballot resulted in a 5-5 tie, the directors were called to Chicago where they met for an unprecedented six-hour meeting. On the sixth secret ballot, one voter sparked a major upset when he switched in favor of the conference's freshman member. Later, it was revealed that Ohio State lobbied on Michigan State's behalf, convincing Indiana to leave the camp supporting Illinois in favor of the Spartans.

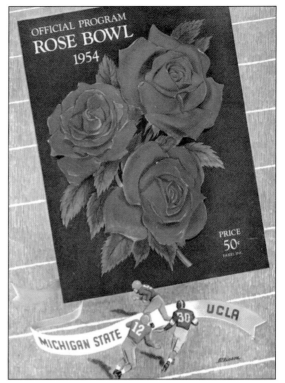

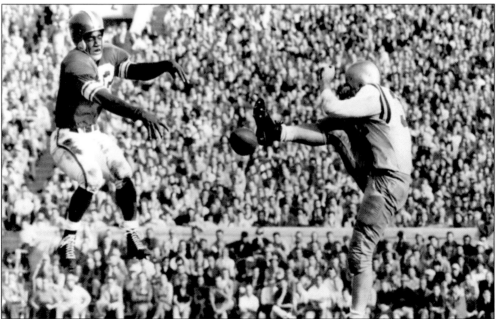

ALL-AMERICAN PLAY. The All-America honors Ellis Duckett earned as a Spartan sophomore in 1952 weren't forthcoming in '53 or '54. But, Duckett made an all-American play, and one of the most famous in Michigan State history, when he blocked UCLA halfback Paul Cameron's punt, gathered in the loose ball at the 6-yard line, and ran in for the touchdown that cut the Bruins' lead to 14-7 with five minutes remaining in the first half of the 1954 Rose Bowl.

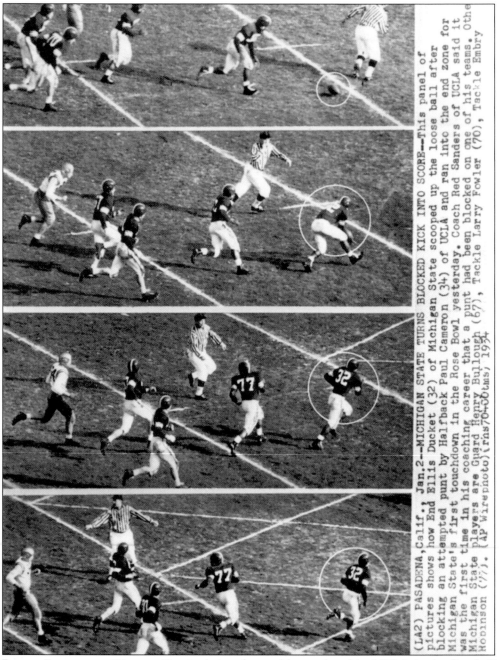

BIGGIE FLIPPED HIS WIGGIE. Despite being thoroughly outplayed by UCLA in the first half of the 1954 Rose Bowl, MSC trailed only by seven points at halftime thanks to Ellis Duckett's blocked punt and return for a touchdown. Coach Biggie Munn said the momentum shifted to the Spartans on the planned play. "It was no fluke," said Munn. "It was one of several kick rushes we worked hard on after studying the movies." Ellis' touchdown was the first of MSC's 28 unanswered points, but the Spartans credited Munn's fiery halftime talk for getting them going. "Biggie flipped his wiggie," wrote Jack Geyer in *The Los Angeles Times*, "because from then on State's pony backfield made donkeys out of UCLA's line."

STAR STUCK. Spartan halfback Billy
Wells was motivated to get MSC to the
Rose Bowl by Hollywood starlet Debbie
Reynolds. Prior to the season, Spartan
sports information director Fred Stabley
asked Wells to name his dream girl.
"And he said Debbie." Stabley said. "I
told Billy, if we went to the Rose Bowl,
I'd get him a date with Reynolds."
Wells danced with Reynolds at the
Big Ten Alumni Banquet preceding
the Rose Bowl game against UCLA.
Wells (No. 14) then waltzed around
the Bruins for a game-high 80 yards
rushing. He scored MSC's go-ahead
touchdown on a 2-yard run with 2:45
left in the third quarter and put the
game out of reach with a 62-yard
punt return with five minutes left in
the game. The Spartans won, 28-20,
and Wells was voted the game's most
outstanding player.

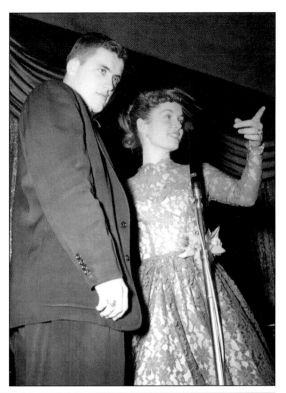

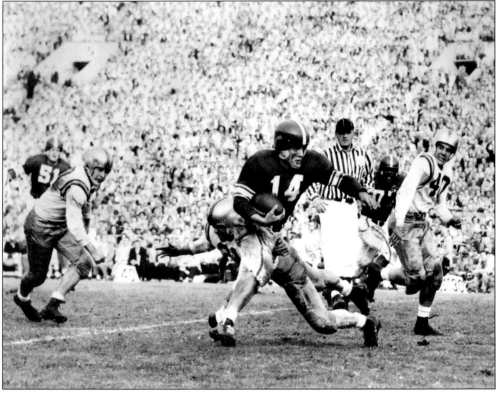

THANKS FOR THE MEMORIES. Michigan State coach Biggie Munn lived it up with Bob Hope (right) and Bob Crosby before the Rose Bowl. After the Spartans beat UCLA, Munn confided in Bruins coach Red Sanders that he was stepping down as coach to replace the retiring Ralph Young as MSC athletic director.

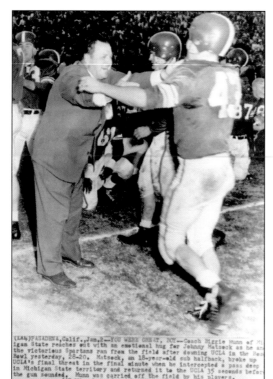

(LA4)PASADENA,Calif.,Jan.2--YOU WERE GREAT, BOY--Coach Biggie Munn of Michigan State reaches out with an emotional hug for Johnny Matsock as he and the victorious Spartans ran from the field after downing UCLA in the Rose Bowl yesterday, 28-20. Matsock, an 18-year-old sub halfback, broke up UCLA's final threat in the final minute when he intercepted a pass deep in Michigan State territory and returned it to the UCLA 35 seconds before the gun sounded. Munn was carried off the field by his players.
(AP Wirephoto)(ifm/JAC2wb)1954.

END OF AN ERA. As the final seconds ticked off MSC's Rose Bowl win over UCLA, Biggie Munn congratulated Johnny Matsock (No. 43), who intercepted a last-ditch Bruin pass in the game's final minute. In his last four seasons as head coach, Munn posted a 35-2 record that included four consecutive wins over Michigan, a 3-0 mark against Notre Dame, and a combined 4-0 showing against Ohio State and Penn State.

FOUR

When Irish Eyes Smiled

THE DUFF. Often times, a head coach who replaces a legend never escapes his shadow, and Biggie Munn created a lot of shade. However, while Munn may have ushered in the Golden Age of Football at Michigan State, his successor, Duffy Daugherty, galvanized it.

"When I was named last winter to succeed Biggie Munn as head coach at Michigan State, there were a lot of fans who shook their heads and murmured: 'Poor Duffy. What a spot he's in. Imagine taking over a team that in the last two years has won a national title, a Big Ten co-championship, and a Rose Bowl game. What can he possibly do except look bad in comparison?' " Daugherty wrote on September 14, 1954. "Well, I want to tell those fans right now that they can save their sympathies. . . . There's no one in the gridiron business who has a better job than mine. I couldn't possibly be happier. Now don't construe that as cockiness. Sure, we're going to lose some football games here and there. What team doesn't? But it's

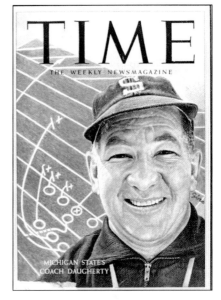

going to be my job to see that the winning tradition established under Biggie is maintained, and I will do everything I can to keep the Spartans in the groove." It might have helped that Daugherty was Munn's protégé. When Daugherty played guard for Syracuse, Munn was his position coach. When Munn became the head coach of the Orangemen in 1946, he added Daugherty to his staff. When Munn moved to Michigan State the following year, he took Daugherty with him. "Like my own son," was how Munn referred to Daugherty back then, though a messy rift developed between the two in the late 1950s.

Daugherty's Spartan teams of the 1950s and '60s were venerated in much the way Miami, Florida State, Nebraska, Oklahoma, Michigan, Ohio State, and Notre Dame are today. Four of his teams were picked as mythical national champions by at least one recognized organization and the two that won Big Ten titles in 1965 and '66 are considered among the greatest in college football history. The perpetual twinkle in Daugherty's his eye gave away his Irish heritage every time, and his quick wit was a thing of legend. His one-liners and wisecracks, known as "Duffyisms," were collected like precious nuggets. For example: Asked at the start of a season who he was happiest to see returning, Daugherty said, with impeccable timing, "Me." Daugherty died in 1987 at the age of 72. "Everyone loved him," said George Webster, a star roverback on MSU's great teams of mid-'60s. "Once you met him, you'd never forget him. He did everything that a father would do. He gave guys from the segregated South, like myself, an opportunity to come to a major university and see if they could make it."

DISAPPOINTING START. The Duffy Daugherty era began on Sept. 25, 1954 with a 14-10 loss at Iowa. Eldean Matheson, who lost his starting halfback job due to a general lack of interest on his part, came off the bench midway through the fourth quarter to set up the Hawkeyes' winning touchdown with a 52-yard punt return. A TV audience of 35 million tuned in, but because of a commercial, fans watching on television in Michigan saw only the final 12 yards of the run. Despite committing six turnovers, the Spartans (white jerseys) had one last chance, but quarterback Earl Morrall was sacked for 16 yards to the MSC 4 yard line, and his fourth-down pass fell incomplete. "They made the most of our mistakes," Daugherty said. It was only the third loss in 39 games for MSC dating back to the final game of 1949.

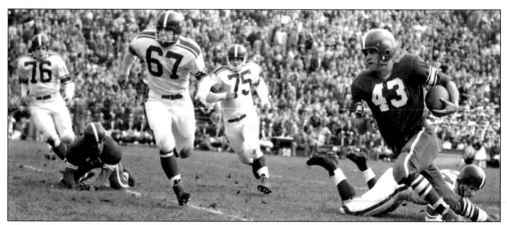

MAYBE IT WAS THE WHITE HELMETS. The Spartans wore green helmets in their 1954 season opener on the road at Iowa, but they made their home debut in white helmets and things went downhill from there. Star halfback LeRoy Bolden injured his leg against Wisconsin, but coach Duffy Daugherty didn't see him lying on the ground behind a wall of photographers. Consequently, Daugherty failed to send in a substitute after Bolden left the field and the Spartan defense lined up with only ten men, who couldn't stop Badger fullback Alan "The Horse" Ameche from rambling for a 38-yard touchdown in the 6-0 MSC defeat. The Spartans abandoned the white helmets after losing their next home game to Purdue, 27-13, for good. Before 1954, Michigan State wore white helmets one other time and lost, 55-0, to Michigan in Biggie Munn's first game as head coach. With a 1-5 start, MSC had as many losses by the sixth game as they had in the previous five seasons combined. The Spartans felt a little better after beating Washington State, 54-6, and halfback John Matsock (No. 43) was one of eight Spartans to score touchdowns against the Cougars. The celebration was short-lived. Michigan broke its four-game losing streak to MSC the following week with a 33-7 win.

THE DOCTOR OF DEFENSE. Michigan State suffered through a disappointing season in 1954, but Hank Bullough (No. 67), closing in for a tackle in the season finale against Marquette, stood out. Bullough was a mainstay at guard on MSU's '52 and '53 championship teams. He went on to even greater success after college and two seasons with the Green Bay Packers. He began a distinguished coaching career as a Michigan State assistant from 1959 to 1969. He was the linebackers coach on the Baltimore Colts 1971 Super Bowl championship team and also worked as the defensive coordinator with the New England Patriots and Cincinnati Bengals. He was the head coach of the USFL Pittsburgh Maulers in '84, and the defensive coordinator and then head coach of the Buffalo Bills in '85 and '86. Known as "Dr. Defense," Bullough returned to the Packers as defensive coordinator for two seasons and held the same post with the Detroit Lions in '93. He completed his career at Michigan State, retiring as the team's defensive coordinator in '94.

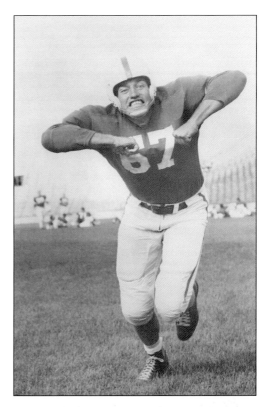

THEY HAD THE PEDAL TO THE METTLE. Led by All-Americans Gerald Planutis (No. 45), Earl Morrall (No. 21), Carl "Buck" Nystrom (No. 68), and Norm Masters (No. 57), newly renamed Michigan State University recovered from its disastrous finish in 1954 by completing the '55 season with a 9-1 record after beating UCLA in the Rose Bowl. Although the Spartans finished No. 2 to Oklahoma in the major polls, they captured the Robert C. Zuppke Award, which went to "The Best Collegiate Team Playing the Toughest Schedule." The trophy is presented by The Athletic Club of Columbus, Ohio. Michigan State's only loss came against Michigan, which finished second in the Big Ten.

BUCK. Carl "Buck" Nystrom was one of the orneriest players ever to suit up for Michigan State. Nystrom won All-America honors as a guard in 1955 for performances like the one he had in a stunning 21-7 victory over No. 4-ranked Notre Dame, which came into Macklin Field undefeated and unscored upon in its first three games. Nystrom played all 60 minutes against the Fighting Irish and was singled out in newspaper accounts for harassing the Notre Dame ball-carriers. Although Nystrom had a toothless grin and a perpetual scab on the bridge of his nose, appearances were deceiving. He was the first Spartan to win both first-team All-America and Academic All-America honors. Nystrom became a nationally acclaimed assistant coach at Northern Michigan, North Dakota State, Oklahoma, Colorado, and Michigan State.

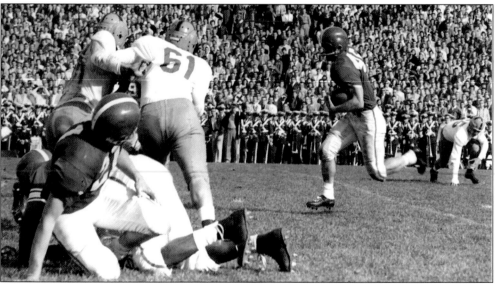

REDEMPTION. In 1954, Gerald Planutis' missed extra point was the difference in the 20-19 loss to Notre Dame. Planutis shed his goat status the following year by scoring one touchdown and setting up another in this 21-7 upset of the fourth-ranked Fighting Irish. "Always a solid player but an unsung hero—until now," said MSU athletic business manager Lyman Frimodig. Planutis broke a 7-7 third-quarter deadlock with a 1-yard plunge into the end zone. He also kicked the conversion. Michigan State got its insurance touchdown after Planutis recovered a fumble at the Irish 9-yard line. Planutis finished the game with 91 yards on 20 carries. He led MSU in scoring in '55 with 52 points and was named All-America fullback.

THE MORRALL OF THE STORY. During his Michigan State career, quarterback Earl Morrall did it all while leading the Spartans to a No. 2 national ranking in '55. Later as a professional, he usually did just enough as a super sub. An All-American his senior year, Morrall was never better than he was in the 21-7 win against Illinois. Morrall completed 5 of 8 passes for 136 yards and two touchdowns—including a 60-yarder to Dave Kaiser—caught a pass for 4 yards, rushed five times for 26 yards, intercepted a pass on defense, and punted four times for a 48-yard average, including a 62-yard quick-kick. Morrall's school record of 274 passing yards against Marquette stood until 1969, he ranked No. 2 in the nation in punting with a 42.9 average and he finished fourth in the Heisman balloting. Morrall still holds the Michigan State record with 7.4 total offense yards per attempt. He played 21 years in the NFL, and was the league MVP for the Baltimore Colts in '68 after taking over for the injured Johnny Unitas. In 1972, he replaced Bob Griese during the Miami Dolphins' 14-0 season. Morrall also appeared in four Super Bowls.

THE NAME SAID IT ALL. Norm Masters was a consensus All-American tackle in 1955 and remains one of the greatest linemen in school history. Friends said Masters was a big softy off the field, but his hard hits on defense earned him the nickname "Stormin' Norman." Said Masters, "I learned to block and tackle hard. There is nothing that makes me feel better than to land a good, solid, clean block." Masters led a Spartan defense that allowed 7.7 points per game. The Spartans also gave up just three touchdowns in their final six games. Masters was drafted in the second round by the NFL Chicago Cardinals but played for the Green Bay Packers from 1957 to 1964.

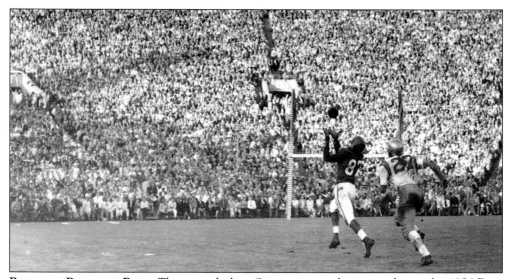

ROSE IS A ROSE IS A ROSE. The second-place Spartans were chosen to play in the 1956 Rose Bowl because the Big Ten's no-repeat rule precluded defending conference champ Ohio State from returning to Pasadena a year after defeating Southern Cal, 20-7. Even so, while MSU finished the regular season with an 8-1 record and the Buckeyes were 9-0, the Spartans were ranked No. 2 in both major final polls while OSU was ranked sixth by the Associated Press and fifth by UPI. Spartan end John "Thunder" Lewis (No. 87) beat UCLA's Bob Davenport on this pass from halfback Clarence Peaks to put MSU ahead, 14-7, with 14:11 remaining in the 1956 Rose Bowl. Lewis caught the ball at the 50 and ran the rest of the way to complete the 67-yard play. It was Lewis' only catch of the game, which MSU won, 17-14.

WHEN KAISER RULED. Dave Kaiser left Notre Dame after his freshman season in 1955 because he didn't think he'd get much of an opportunity to play. The Fighting Irish's loss was MSU's gain. With time running out on the 1956 Rose Bowl and the score between MSU and UCLA tied at 14-14, coach Duffy Daugherty called for a field-goal attempt. But he didn't send in Jerry Planutis, who already missed twice. Instead, he called on Kaiser, a sophomore who had missed on his two previous college tries earlier in the season. After the Bruins were assessed a 5-yard penalty for calling too many time-outs, Kaiser's 41-yard boot split the uprights with seven seconds remaining. "I wasn't sure I made it until the official near me . . . raised his arms, and then [team captain] Buck Nystrom swarmed all over me." The play brought Kaiser instant immortality. Before becoming the first Spartan inducted into the Rose Bowl Hall of Fame in 1999, Kaiser told *The Lansing State Journal*, "It's amazing how many people still remember that kick. People seem to remember where they were when that happened like they do when JFK was shot."

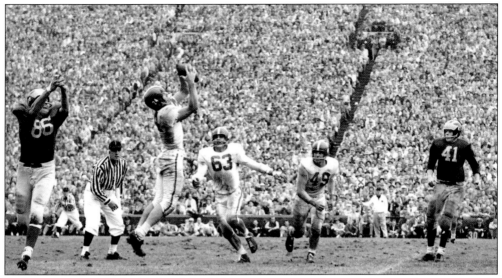

BREAKTHROUGH. The highlight of the 1956 season came in the second game when coach Duffy Daugherty got his first win over Michigan, 9-0, in Ann Arbor. The victory broke a two-game losing streak to the Wolverines, but was MSU's fifth against UM in the last seven games. Late in the third quarter, Pat Wilson (No. 24) preserved a 3-0 lead with this interception of a Jim Maddock pass deep in Spartan territory. "It was the hardest-fought game I've ever seen," Daugherty said.

AN OFFER HE COULDN'T REFUSE. James Caan, shown during a 1977 campus visit, played one season of football at MSU as a 16-year-old freshman quarterback in 1956 and then transferred to New York University. Then he left school to become an actor and made it big in Hollywood after landing the role of Sonny Corleone in "The Godfather" and Chicago Bears running back Brian Piccolo in "Brian's Song." In 1981, Caan told *Inside Sports Magazine*: "I recently saw Duffy Daugherty . . . at a track and he said, 'Here's one of my dummies,' and he called me over. 'I should be getting 10 percent of your salary,' he told me. 'I'm the one who convinced you to quit football.'"

BY THE NUMBERS. Michigan State made numerous strides in 1957. Upper decks were added to Macklin Field, increasing capacity to 76,000 and giving the stadium its current profile. The facility also became officially known as Spartan Stadium. Led by All-Americans Dan Currie (No. 55) and Walt Kowalczyk (No. 14), the Spartans finished 8-1 and won their fourth national title as selected by Billingsly, by Dunkel, and by Sagarin. Purdue again spoiled MSU's bid for an undefeated season with a 20-13 upset.

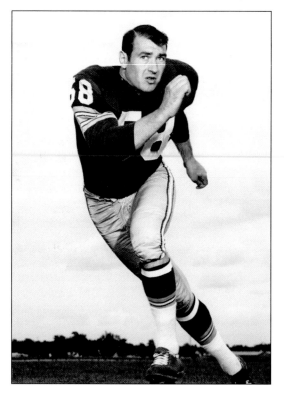

THE CURE FOR BAD DEFENSE. Before Dan Currie became an All-Pro linebacker for the Green Bay Packers as No. 58, he was leveling opposing ball-carriers with his broad shoulders as No. 55 for the Michigan State Spartans. With Currie leading the defense, MSU shut out its first two opponents of 1957, Indiana and California, by the combined score of 73-0. The Spartans led the Big Ten and were third nationally in total defense. Currie also started at center on a Spartan offense that led the Big Ten in total yardage and scoring. The Packers drafted Currie in the first round and he played seven NFL seasons.

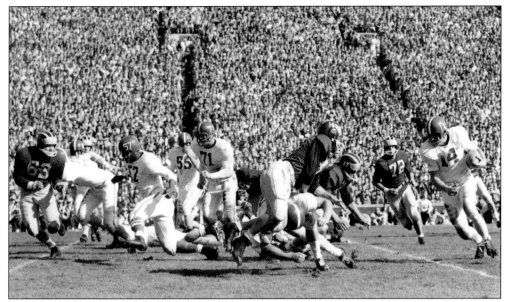

THE MIGHTY SMITHY. UCLA coach Red Sanders honored Spartan halfback Walt Kowalczyk by dubbing him the "Sprinting Blacksmith" because of the way he hammered the Bruins during his MVP performance in the '56 Rose Bowl. But Kowalczyk honored the No. 14 jersey previously worn by MSU running greats Lynn Chandnois and Billy Wells with an outstanding senior season, when he was named All-American in '57. The punishing runner from Westfield, Massachusetts ran for a career-best 113 yards and a touchdown while leading the Spartans to this 35-6 demolition of Michigan. Kowalczyk averaged 5.4 yards per carry, scored at least one touchdown in eight of nine games, and finished third in voting for the Heisman Trophy in his final season.

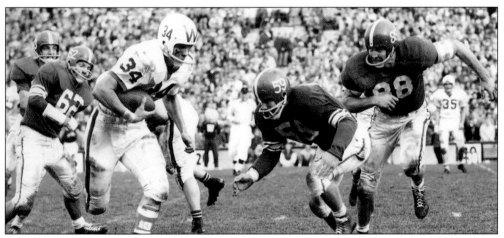

SOMEONE TO BRAG ABOUT. It's not easy for a player on a losing team to earn All-America honors, but Michigan State end Sam Williams (No. 88) stood out so conspicuously he couldn't be denied postseason honors in 1958. Williams returned to MSU after leaving school to serve four years in the U.S. Navy. Williams led the Spartans in receiving as a senior with 15 catches for 242 yards, but his forte was defense. He had 13 solo tackles against Michigan, Illinois, and Purdue ran most of their plays away from Williams. He was a member of the NFL's original Fearsome Foursome while playing for the Detroit Lions alongside Alex Karras, Roger Brown, and Darris McCord. Williams finished his professional career with the Atlanta Falcons.

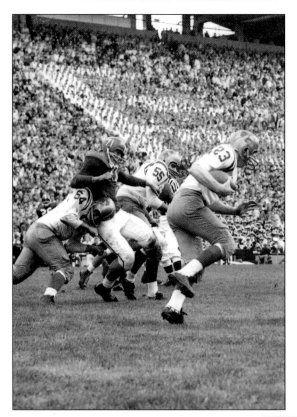

PRO PREVIEW. Notre Dame sophomore guard Nick Buoniconti (No. 64, white jersey) got the best of Michigan State sophomore linebacker Dave Manders (No. 71, dark jersey) on this play in the 1959 game between the Fighting Irish and Spartans in East Lansing. But Manders got the last laugh in the game because MSU prevailed, 19-0. Buoniconti and Manders were adversaries for years to come. Neither were All-Americans in college, but both became Pro Bowl players in the NFL. Manders played center for ten seasons with the Dallas Cowboys and Buoniconti starred as a middle linebacker for the Boston Patriots and Miami Dolphins.

NEVER OVERLOOKED. Dean Look has worn many hats during an illustrious athletic career. He was a first-team All-Big Ten baseball outfielder who attracted a $50,000 contract from the Chicago White Sox. Look began his Spartan football career as a halfback and returned a punt 92 yards for a touchdown against Michigan in '58. He switched to quarterback in 1959 and in a 15-10 victory over Northwestern, completed all seven of his passes. He ended the season completing 49 of 100 for 785 yards and two touchdowns while earning All-America accolades from *Look Magazine*, among others. "Dean Look . . . never loses his poise . . . never panics," Coach Duffy Daugherty said of his MVP. Those qualities served him well during his 29 seasons as an NFL on-field official. A long-time side judge, Look signaled touchdown on "The Catch"— Dwight Clark's leaping grab that gave the San Francisco 49ers victory over Dallas in the 1981 NFC Championship. Look worked several Super Bowls and retired from active officiating in 2002.

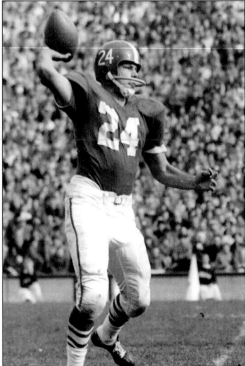

BREEDING GROUND. Michigan State's reputation for turning out players who were ready for professional football began to blossom in the 1960s. The bar was raised by halfback Herb Adderley, shown receiving an award from former Spartan offensive tackle and graduate assistant coach George Perles after the MSU Varsity vs. Spartan Old-timers Game in May 1960. Although Adderley didn't add All-America honors to his All-Big Ten accolades, he was a first-round pick the of the Green Bay Packers. He became the first player to compete in four Super Bowls—numbers I and II with the Green Bay Packers, V and VI with the Dallas Cowboys. After an All-Pro career, in 1980 Adderley became the first Spartan to be enshrined in the Pro Football Hall of Fame. Perles eventually became a top assistant coach with the Pittsburgh Steelers and, later, the head coach of his beloved Spartans.

AMAZING TALES. Back in the heyday of the American Football League, there weren't many bigger names than Fred Arbanas of Kansas City Chiefs. However, Arbanas was groomed to be the AFL's all-time tight end, as selected by the Pro Football Hall of Fame in 1970, at Michigan State. His biggest day as a Spartan came as a junior in '59 when he had 67 yards on four receptions, including one for a 52-yard touchdown, in the 19-0 victory over Notre Dame. Arbanas starred on defense as a senior, and though he caught only three passes, two were for touchdowns. Interestingly enough, he scored a touchdown on the first reception of his career in the '58 season opener against California, and on the last, in the 1960 finale against the University of Detroit. Even more astounding was the fact that he played the final six seasons of his nine-year pro career after being blinded in the left eye by a mugger on December 8, 1964.

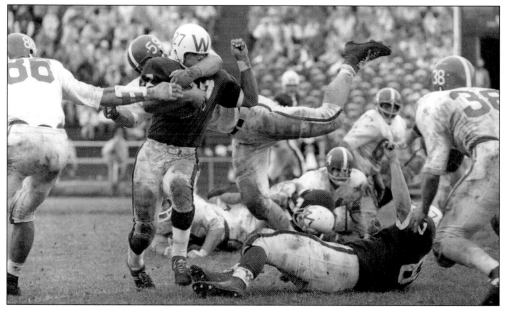

OFF AND FLYING. Sophomore defensive lineman Dan Underwood got the Spartans off to a flying start in '61 with this punishing hit on Wisconsin halfback Louis Holland. The 20-0 victory in Madison was the first of five straight wins, including a 28-0 whitewash at Michigan—MSU's sixth in a row against the Wolverines without a loss—and a sixth consecutive win over Notre Dame.

POWER FOOTBALL. Michigan State coach Duffy Daugherty (middle) entered the era of power football with the likes of linemen Dave Behrman (right) and Ed Budde (left). Gone were the smallish, swift linemen that made State's offense go in the '50s. At 6-foot-4, 247 pounds, Behrman was a bear of a man— and that was after he shed 30 pounds after leaving Dowagiac (Michigan) High School. He earned All-America honors in 1961 and All-Big Ten accolades in '61 and '62. Behrman played for the Buffalo Bills from 1963 to 1967. At 6-foot-4, 243, Budde was named All-America in '62, but inexplicably rated no better than honorable mention All-Big Ten honors. Not that it mattered. Budde went on to have a stellar, 14-year professional career as a defensive end with the Kansas City Chiefs, garnering All-Pro status seven times and playing in two Super Bowls. Budde's sons, Brad and John, starred at Southern Cal and Michigan State, respectively.

DEWEY BEATS MICHIGAN. "Michigan State's magnificent Spartans showing awesome strength in the line and shaking loose a halfback for one of the most memorable running performances in history here, crumpled Michigan in their traditional football collision. . . ." So began Clank Stoppels in *The Grand Rapids Press'* account of the 1962 game between Spartans and Wolverines. Dewey Lincoln (No. 26) rushed seven times for 139 yards and had a 64-yard scoring run nullified by a penalty in MSU's second straight 28-0 victory over UM. Despite losing five of seven fumbles, the Spartans beat Michigan for the fourth time in a row and extended their unbeaten streak against UM to seven games.

THE IRON MAN. He spent his summers running with eight-pound weights on his ankles. He spent autumn Saturday's hitting opponents like a ton of bricks. MSU's George Saimes, shown gaining some of his career-best 153 yards in the 31-7 victory over Notre Dame, was a consensus All-America and All-Big Ten fullback in '62. After Saimes scored on runs of 54, 49, and 15 yards in the MSU's seventh straight win over the Fighting Irish, Spartan coach Duffy Daugherty said, "He has to be the greatest football player anywhere today. He is a coach's dream, the perfect athlete, the complete player." As a senior, Saimes led the Spartans in rushing with 642 yards, nine of his 18 career touchdowns, and had three interceptions on defense. Saimes starred as a defensive back for the Buffalo Bills from 1963 to 1969 and finished out his professional career with the Denver Broncos in '72. He was named to the Bills Silver Anniversary team in '84.

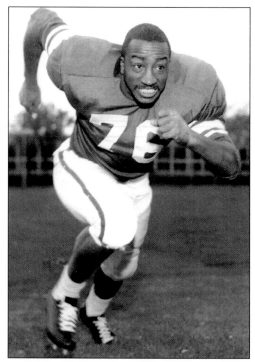

TRANSFORMER. The move from fullback to offensive line in 1963 was a good one for Earl Lattimer. There wasn't much work available in the loaded Spartan backfield, and Lattimer had an opportunity to get noticed as a guard—and not just for occasionally somersaulting out of the huddle. "It was more or less a chance for me to play and I don't care where I played as long as I played," said Lattimer, who was named All-America by the *New York News*. Against Northwestern, Lattimer's first career field-goal attempt was good for a then-school record 47 yards, and at the time was the third longest in Big Ten history. The following week, with the athletic Lattimer bulldozing open holes, the Spartans rolled up 273 yards in the 30-13 upset of No. 8-ranked Wisconsin. As a linebacker, Lattimer helped hold the Badgers to 29 yards on the ground and also intercepted a pass. And on special teams, Lattimer kicked a 44-yard field goal into a 17 mph wind.

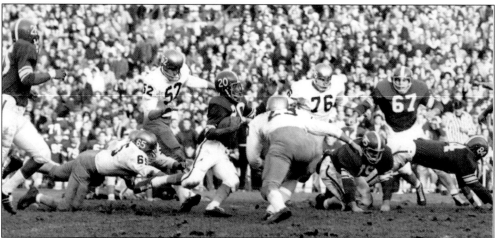

LEWIS OF LOUISVILLE. According to MSU coach Duffy Daugherty, Spartan scatback Sherman Lewis had one weakness in 1963, and it decidedly wasn't his size even though he only stood 5-foot-8 and weighed 152 pounds. "He's a senior," Daugherty quipped. He also was the year's most spectacular All-American while leading Michigan State in rushing and receiving. His 88-yard reception against Southern Cal and his 87-yarder against Wisconsin were MSU's two longest pass plays up to that time and ranked second and third going into the 2003 season. He scored on an 87-yard run and an 84-yard punt return in a 15-7 win against Northwestern, and shown here in the 12-7 victory over Notre Dame, scored on runs of 3 and 85 yards while rushing for 138 on 10 carries. Lewis finished third in the Heisman voting and was the Football News College Player of the Year. After a brief pro career, Lewis was a 14-year assistant coach at Michigan State and then spent more than 20 years as a prominent assistant and offensive coordinator in the NFL with stops at San Francisco, Green Bay, Minnesota, and Detroit.

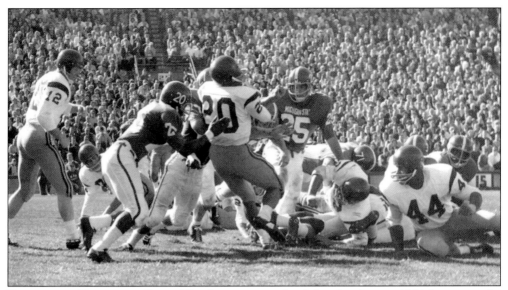

PORTENT OF THINGS TO COME. The Spartans were loaded with talent in 1964, but most of it belonged to juniors and sophomores and their inexperience showed en route to a 4-5 record. But in the second game, they demonstrated their potential by upsetting No. 2-ranked Southern Cal, 17-7, in Spartan Stadium. The Spartans, led by defensive halfback Don Japinga, held star Trojan running back Mike Garrett (No. 20 in white) to 94 yards and a 1-yard touchdown on 26 carries. "We tried a 1,000 ways to fool him and never did," USC coach John McKay said of Japinga. Garrett would win the Heisman Trophy in '65, but MSU would win even more that season.

CONSENSUS NATIONAL CHAMPS. The 1965 season began and ended for Michigan State against UCLA. Led by eight All-Americans—Ron Goovert (No. 61), Clint Jones (third row, third from right), co-captain Steve Juday (No. 23), Harold Lucas (No. 51), Bubba Smith (No. 95), Gene Washington (No. 84), and George Webster (No. 90)—and co-captain and first-team Academic All-American Don Japinga (No. 14), the Spartans were undefeated in ten regular season games and undisputed Big Ten champs. Their only loss, after they were already crowned national champions, came against the Bruins in the Rose Bowl.

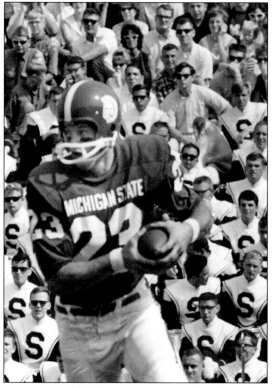

JUDAY, JUDAY, JUDAY. Steve Juday sauntered into Michigan State's quarterback domain as a sophomore, and then subtly conquered it. By his senior year in '65, Juday was the complete field general—effective with his arm, his feet, and his mind—leading MSU to come-from-behind victories six times. As a record-setting senior, Juday (No. 23) was the first Spartan to throw for 1,000 yards, completing 89 of 168 passes for 1,173 yards and seven touchdowns. Named All-American, All-Big Ten, Academic All-America, and Academic All-Big Ten, Juday finished sixth in the Heisman race. Juday also was awarded the Big Ten Conference Medal of Honor, its highest award. In 1994, Juday, by then a distinguished alum, told *Spartan Magazine*'s Jim Comparoni that he wouldn't have turned down the Heisman, "but I'd rather hang my hat on going 10-0 and being chosen to some academic teams."

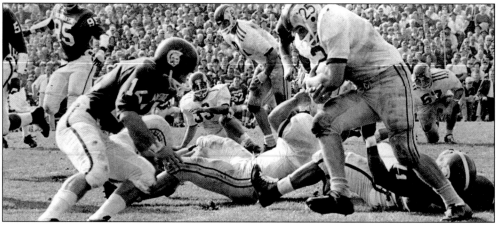

HIGH PERFORMANCE. Don Japinga was like a hot rod—undersized and overpowered. At 5-foot-7 and 155 pounds, Japinga (No. 14) was the smallest member of the team. But, he had the biggest heart. His enthusiasm was infectious and his leadership irresistible. "It doesn't matter the size of the dog in the fight," Japinga once said in 1965. "It's the size of the fight in the dog that counts." A walk-on who earned a scholarship and became a first-team All-Big Ten and Academic All-America selection, Japinga was renowned for sniffing out plays and shutting down receivers who were seven to ten inches taller. "People ask how in the world a boy Japinga's size can cover the giant ends you find in major college football today," said Coach Duffy Daugherty. "The answer is he does it with speed, agility and bounce." Japinga, who had four interceptions in '65, also wasn't afraid of putting a hit on an opponent, like he did in this collision with Ohio State fullback Tom Barrington (No. 25).

IN THE GROOVE. When you played alongside Bubba Smith and George Webster, it would have been understandable to be overlooked. But Michigan State linebacker Ron Goovert was outstanding in his own right; he was named All-American and All-Big Ten along with Smith and Webster in '65. "Ron Goovert without a doubt is the finest linebacker in the Big Ten," said Spartan coach Duffy Daugherty, who later expanded Goovert's superiority to the rest of the nation. In a 24-7 demolition of defending Big Ten and Rose Bowl champ Michigan, Goovert led a defense that tackled Wolverine running backs for an astounding minus-39 yards rushing. Ohio State quarterback Don Unverferth (No. 26) got this pass off before being broken in half by Goovert's hard hit, but Goovert caught him in the end zone earlier in the game for a safety in MSU's 32-7 win. Goovert led MSU to a crucial 14-10 win over sixth-ranked Purdue by ending the Boilermakers' first scoring threat with an interception and making the sack that set up the Spartans' game-winning touchdown.

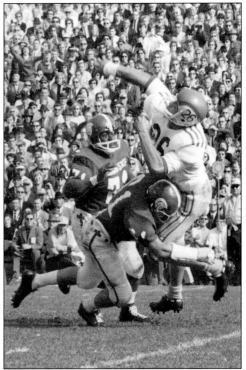

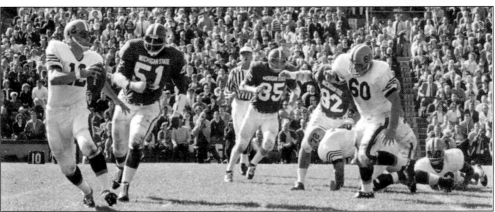

BIGGEST AND BADDEST. There never had been a Michigan State player as big as 286-pound middle guard Harold Lucas (No. 51), seen here chasing down Illinois quarterback Fred Custardo. Thick but maneuverable, Lucas anchored one of the most formidable lines—which included ends Bob Viney (No. 85) and Bubba Smith, and tackles Don Bierowicz and Buddy Owens—in college football history. "I like to look at my man in the eye and see how he reacts," said Lucas, revealing a nasty streak in *The Detroit Free Press*. "It's sort of fun to get the feel of him, mess him up, bend him a little." The Spartans bent many an offense until it looked like a pretzel. Against MSU, Ohio State recorded negative rushing yardage—minus-22 yards—for the first time in Buckeye history. Plus, OSU, the epitome of three-yards-and-a-cloud-of-dust teams, didn't try a running play in the second half. After trying to move Lucas out of the way with every bit of power at his disposal, a Northwestern halfback told Wildcat coach Alex Agase, "Coach, he didn't even bend." The Spartans allowed a nation-leading 45.6 yards on the ground, and a mere 34.6 against Big Ten teams.

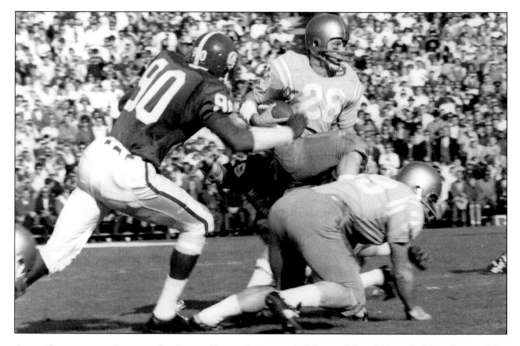

ANTI-CLIMACTIC. Despite the best efforts of George Webster (No. 90) and Clint Jones (No. 26)—who rushed for 113 yards—Michigan State's three-game win streak over UCLA came to an end in the 1966 Rose Bowl. Amazingly, the Spartans were still in it at the end despite committing five turnovers, failing on a pair of two-point conversions, and missing a 23-yard field-goal attempt before falling, 14-12. In an interview with *Spartan Magazine* 28 years later, Juday, who was responsible for four turnovers, came to an understanding of what happened to MSU on that day. "I've only had thirty years to think about it," Juday mused, "and this is what happened: when you play every week you don't have time to read your press clippings. When you take six weeks between games, all kinds of things can happen to your mind. And they did. We had that time to really enjoy the glory of being number one. Shame on us, but we were just kids."

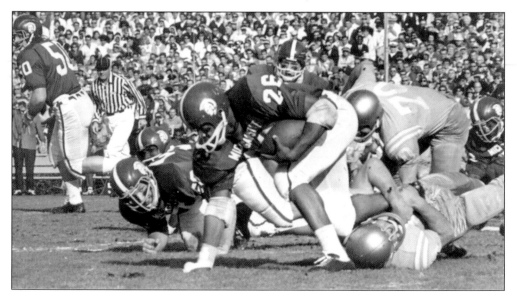

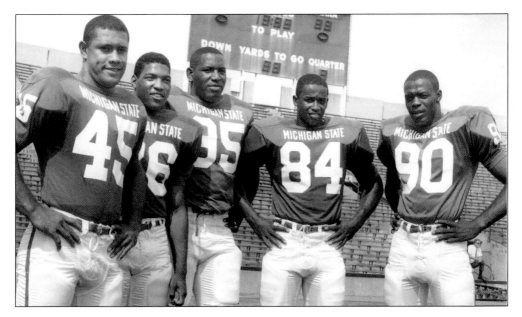

RETURNING ALL-AMERICANS. As underclassmen, (left to right) fullback Bob Apisa, halfback Clint Jones, defensive end Bubba Smith, wide receiver Gene Washington, and roverback George Webster earned All-America honors in 1965. Each would repeat in '66, and their ranks would be joined by offensive tackle Jerry West (No. 67). Those six, plus linebacker Charlie "Mad Dog" Thornhill, defensive tackle Nicholas Jordan, offensive guard Anthony Conti, defensive back Jess Phillips, and kicker Dick Kenney were named first-team All-Big Ten. Quarterback Jimmy Raye, defensive linemen Patrick Gallinagh and Phillip Hoag, and offensive linemen Joe Pryzbycki and Jeffrey Richardson made the second team. Defensive end George Chatlos, end Allen Brenner—who would be named All-American in 1968—halfback Dwight Lee, defensive back Drake Garrett, and fullback Regis Cavender picked up honorable mentions. Twenty-one in all were honored. One of the greatest assemblages of talent in college football history was rivaled that year only by Notre Dame.

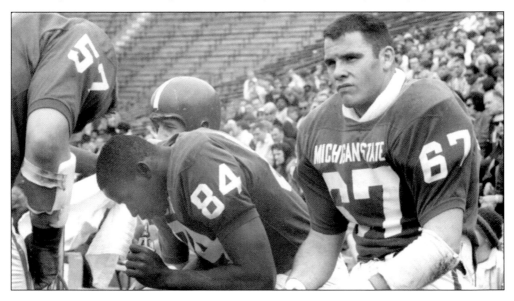

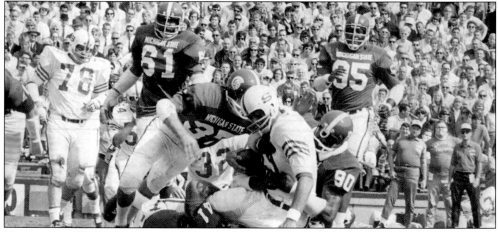

WORTHY OF HIS NICKNAME. In the second quarter of the 1966 season opener against North Carolina State, senior linebacker Charles "Mad Dog" Thornhill (No. 41) tore into Wolfpack quarterback Charlie Noggle, and George Webster (No. 90), Paul Lawson (No. 37), Charles Bailey (No. 61), and Bubba Smith (No. 95) helped finish him off, thereby setting the tone for the season. The Spartans outrushed N.C. State 360-27 in the 28-10 victory. Thornhill came to MSU, from Roanoke, Virginia, known as Big Dog. "I got that . . . label when I was about ten because I was pretty aggressive," the chiseled 5-foot-10, 201-pound Thornhill recalled. "Then one day at Michigan State, one of the coaches punched me in the chest pretty hard. I told him, 'Don't you put your hands on me.' The coach yelled, 'Man, you're a Mad Dog,' and that name's been with me ever since." Thornhill, who moved from fullback and guard before finding a home at linebacker, set a team record with 102 tackles while terrorizing running backs in '66.

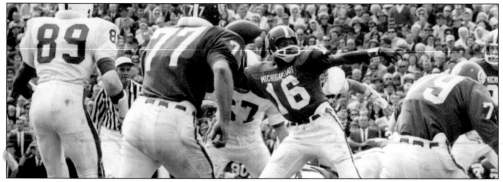

A RAYE GUN. Quarterback Jimmy Raye could ignite the offense, and the crowd, with his electrifying play. "In all my years, on a bootleg option, the first priority is for the quarterback to pass," Coach Duffy Daugherty said. "Then, if all the receivers are covered or if the quarterback sees some running room, he'll take the option and run with the ball. We use the same action—the receivers go downfield, as the regular option play, but instead of thinking first of passing, (Raye) has orders to run with the ball first. If he can't make yardage running, then he'll pass." In the 42-8 pasting of Penn State, Raye arrived as a passer. Although he completed only 4 of 10 passes for 88 yards, two of his throws went for 36- and 50-yard touchdowns to Gene Washington. He also gained 31 yards on 12 carries. "Raye . . . gets them out of the hole so often with the big third-down plays," said Nittany Lions coach Joe Paterno. Raye played four years in the NFL and then became an assistant coach at MSU, Texas, and Wyoming before moving on to the NFL where he has been an assistant or offensive coordinator at San Francisco, Detroit, Atlanta, Los Angeles Rams, Tampa Bay, New England, Washington, and the New York Jets.

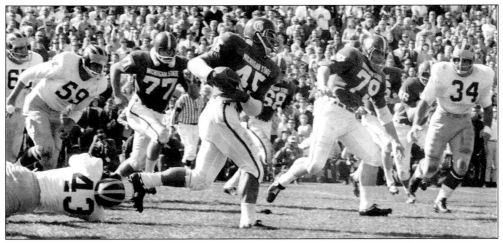

THERE WAS NO APPEASING APISA. Michigan State fullback Bob Apisa made an impact as a sophomore and junior, earning All-America honors each season despite having his playing time curtailed by knee injuries. Known as the "Samoan Bull," Apisa (No. 45), following blocker Joe Przybycki (No. 79), rambled for a career-best 140 yards, including a 6-yard touchdown, in the 20-6 lip-splitting defeat of the Wolverines in 1966. Apisa was one of a handful of effective players Coach Duffy Daugherty recruited from Hawaii in the '60s. Apisa completed his Spartan career in '67 as MSU's most productive fullback ever, with 1,343 yards on 262 carries. Since 1970, Apisa has been a member of the Screen Actors Guild, working in Hollywood as an actor and stuntman. He has appeared in more than 30 television shows, including: "Hawaii Five-O," "Magnum P.I.," and "Hill Street Blues," and more than 30 television movies and feature films, including "Tango & Cash," "Code Name Zebra," "Ricochet," and "Another 48 Hours."

DICK "THE TOES" KENNEY. Michigan State's closest call on the way to their date with destiny against Notre Dame in '66 came at Ohio State in Game No. 5. Dick Kenney, the Spartans' Hawaiian-born kicker, who added to MSU's national aura by launching balls barefooted, was the difference in the game. What may be long forgotten is that Kenney's bare hand was just as instrumental in the 11-8 win as his naked toes. Kenney put the Spartans ahead 3-2 with a 27-yard field goal in the third quarter, but the Buckeyes took an 8-3 lead early in the fourth quarter. After fullback Bob Apisa made it 9-8 in MSU's favor with a 1-yard plunge on fourth down, Kenney lined up to kick the extra point. However, Kenney took a direct snap from center instead, and passed to 5-foot-7 holder Charlie Wedemeyer for the 2-point conversion. "I cringe every time he drives his toes into the ball," coach Duffy Daugherty said.

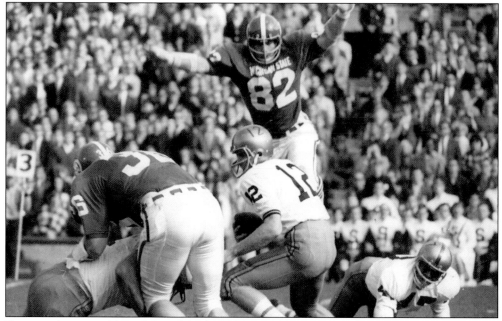

PASSING ANOTHER TEST. It's not like the '66 Spartans weren't tested. Although MSU defensive end George Chatlos (No. 82) devoured Purdue's Bob Griese on this play, the Boilermakers' All-American quarterback completed 17 of 29 passes for 183 yards, and he ran for two touchdowns. However, Griese didn't throw a touchdown pass, while Spartan QB Jimmy Raye hit on 10 of 17 for 159 yards and one touchdown in the 41-20 MSU victory.

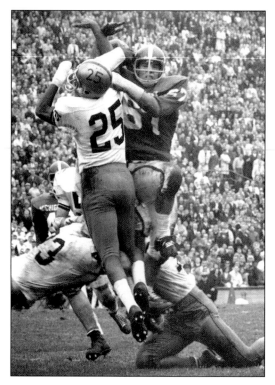

MSU RAN BEST WHEN IT RAN TOWARD WEST. Michigan State's punishing ground attack didn't lead the Big Ten with 223.2 yards per game just because Clint Jones, Bob Apisa and Dick Gordon were outstanding running backs. The blocking of 5-foot-11, 218-pound Jerry West (No. 67), battling Purdue's John Charles (No. 25) for Gordon's fumble—the ball is left of West's helmet—also played a big role. The Spartans rushed for 198 yards to Purdue's 72 in that game. But West's claim to All-America honors may have been staked against Ohio State when his pass protection helped quarterback Jimmy Raye pass for 68 yards on MSU's 83-yard game-winning touchdown drive. "He's a three-year regular on good teams (and) he's never missed a game," said coach Duffy Daugherty. "I can't think of a more genuine All-American."

A STREAK. In the Oct. 10, 1966 issue of Sports Illustrated, MSU's Clinton Jones was listed among the college halfbacks it called the streaks—". . . fast and tough and exciting . . . the newest and brightest twist in a game that has gone all out on attack". The magazine ranked Jones behind UCLA's Mel Farr and Arkansas' Harry Jones, but ahead of Notre Dame's Nick Eddy and Houston's Warren McVea. And on a snowy day in East Lansing, Jones showed why he belonged by setting a Big Ten single-game rushing record with 268 yards, on just 21 carries. Jones scored on touchdown runs of 79, 70 and 2 yards in the 56-7 romp. Before the game, Jones apologized to his teammates for what he regarded as sub-par play. "I told them I didn't want to end my last year feeling that I'd let the team down, or Duffy or my family," said Jones, who went on to win the Big Ten rushing title and All-America honors.

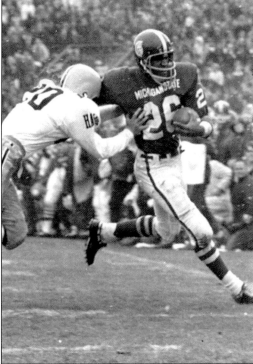

MICHIGAN STATE Spartans
NOTRE DAME Fighting Irish

SPARTAN GRIDIRON NEWS 50¢ Souvenir Program November 19, 1966 SPARTAN STADIUM Kickoff 1:30 p.m.

THE ONE THAT STARTED IT ALL. On November 19, 1966, No. 2-ranked and undefeated Michigan State hosted No. 1 and unbeaten Notre Dame in Spartan Stadium. No game before it—college or professional—had receive so much pre-kickoff hype, and this game alone forever changed the landscape of sports. More than 700 sportswriters from across the nation descended on East Lansing to cover it, 80,011 squeezed into the 76,000-seat facility to watch it and another 33 million tuned in on TV. Thirty-one future NFL players, including ten first-rounders, played in the game. And, because it ended in a controversial 10-10 tie after Irish coach Ara Parseghian decided to sit on the ball instead of gambling from deep in his own territory, it lives on in arguments over which really was the greater team. ABC play-by-play announcer Chris Schenkel, who called the game, characterized this particular "Game of the Century" in these terms, "It was really the game that started it all."

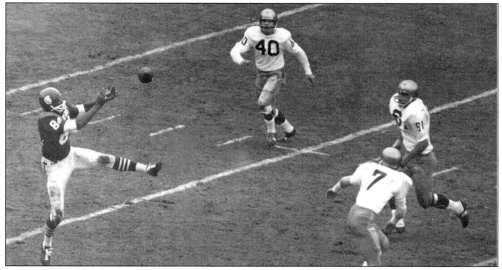

GENE THE MACHINE. Spartan split end Gene Washington got behind Notre Dame safety Tom Schoen (No. 7) and defensive halfback Tom O'Leary (No. 40) to make this circus catch. Washington put on a virtuoso performance in his final game for MSU, hauling in five passes for 123 yards. Washington had better statistical games — 143 yards on four catches against Penn State; nine catches for 150 yards in the victory over the Fighting Irish the previous season—but the nation hung on each one of his grabs in his grand finale. An Academic All-American as well, Washington went on to have an outstanding All-Pro NFL career with the Minnesota Vikings. After his playing career, he became a top executive with the 3M Corp.

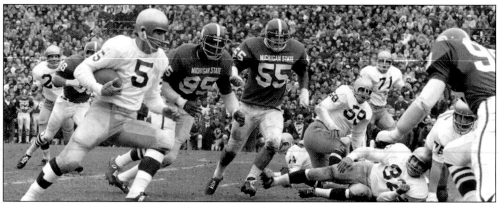

SMITH THE MYTH? Before MSU played Northwestern late in the '66 season, a sportswriter referred to Spartan defensive end Charles "Bubba" Smith as "a myth," and the "Kill Bubba, Kill!" chants shouted in Spartan Stadium as baseless. The wag wrote that Smith was a paper tiger, soft, all hype and not much else. However, Notre Dame starting quarterback Terry Hanratty (No. 5) will attest that it wasn't something as ethereal as myth that knocked him out in the first quarter with a shoulder injury. It was Smith (No. 95) who had him in his sights and took him out. The 6-foot-8, 280-pound Smith became a larger-than-life figure for Michigan State on and off the field. Opponents sent two or three blockers at him, or would simply run the other way. Although he had only 30 tackles, including ten behind the line, in '66, UPI named him its Lineman of the Year and the Baltimore Colts drafted him No. 1 overall—the first Spartan to earn that distinction. He was inducted into the College Football Hall of Fame in '88 and has had a successful acting career, gaining his most acclaim in the "Police Academy" movies.

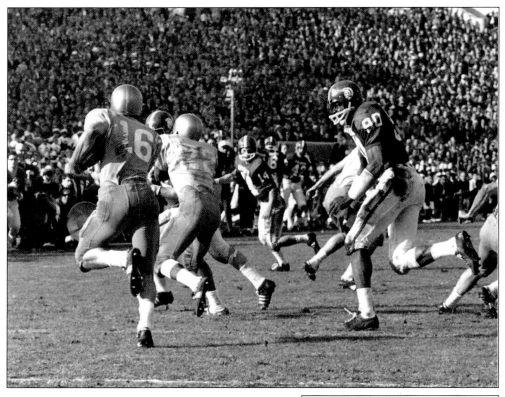

THE GREATEST. The surest sign of athletic greatness is the ability to change the way a game is played. George Webster did that for college football when he was a two-time All-America roverback for MSU, Spartan MVP in '66 and linchpin in the greatest defense the Big Ten has ever known. "He doesn't tackle people, he explodes them," MSU coach Duffy Daugherty once said. Part linebacker part defensive back, opposing teams never knew where Webster, called "Mickey" by some, would line up. Sometimes it was at end, linebacker or safety. "Mickey possesses three things that make him one of the best," said Spartan defensive backfield coach Vince Carillot. "He can hit like a linebacker. He has the speed to cover deep on passes. And he has that thing you can't coach—sthe knack of being where the offense is going to try to go with the football." In a vote of Spartan fans in 1969, Webster was named MSU's all-time Greatest Player, and there have been few since who could challenge that claim. Webster was drafted in the first round by the Houston Oilers and he played ten NFL seasons, including stints in Pittsburgh and New England. In 1987, Webster was inducted into the College Football Hall of Fame, but in recent years, he has been in a battle for his life against several serious ailments, including circulation problems in his legs and throat cancer.

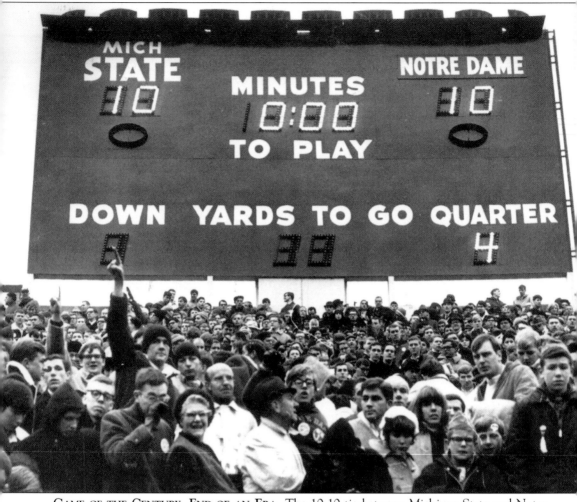

GAME OF THE CENTURY, END OF AN ERA. The 10-10 tie between Michigan State and Notre Dame represented a bittersweet high-water mark of MSU football. The Spartans won another undisputed Big Ten championship, but couldn't even play in the Rose Bowl because of the league's myopic no-repeat rule. Notre Dame coach Ara Parseghian was called "yellow" for not going for the win when his team had the ball last, but the Fighting Irish got the mythical national championship from both major polls. Spartan coach Duffy Daugherty split his No. 1 vote in the UPI coaches' poll and MSU settled for No. 2. Game films showed the Irish got the benefit of two bad calls—an erroneous offside violation by Bubba Smith, which nullified a fumble recovery by MSU and allowed Notre Dame to kick the tying field goal, and an official's ruling that negated a Spartan fumble recovery on the last punt of the game that would have given MSU the ball at the Irish 30 in the dying stages of the game. Michigan State was named national champs by the National Football Foundation, which awards the MacArthur Bowl, but it was shared with Notre Dame. What the tie ensured is that it could only be broken by the minds of men, and in that regard, to this day it's one opinion versus another. One that favored MSU belonged to *New York World Journal Tribune* columnist Jimmy Cannon who so eloquently wrote: "The better team on the field was Michigan State. The stickout coach was Daugherty. Michigan State had more style. So did its coach. There is no doubt that Michigan (sic) was rougher, although Notre Dame was heavier. Daugherty took his chances with the poise of a man who understands he can be hurt if he's wrong. Parseghian played not to lose. One is a champion. The other isn't."

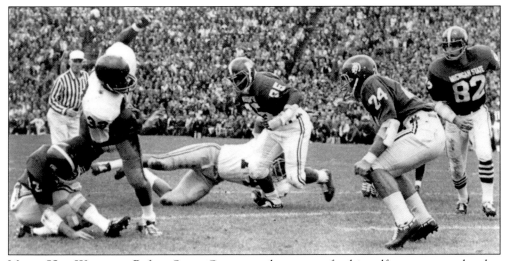

MULTI-HIT WONDER. Before Steve Garvey made a name for himself as a too-good-to-be-true baseball hitting star with the Los Angeles Dodgers and San Diego Padres, he started at cornerback for the Spartans. Garvey (No. 24) didn't do much to stop Southern Cal junior tailback O.J. Simpson (No. 32), who rushed for 190 yards and two touchdowns in the Trojans' 21-17 victory at Spartan Stadium on September 30, 1967. In his only varsity season, Garvey had no interceptions and was 14th on the team in tackles with a total of 30, including eight solos and 22 assists. He then answered his true calling in life and signed with the Dodgers. "Garvey was a baseball player who played football," former MSU baseball coach Danny Litwhiler told *The Lansing State Journal* in 1984.

MULTI-TASKER. Several players have appeared in games on offense and defense at the Division-I level since 1968. Michigan's Charles Woodson and Ohio State's Chris Gamble come to mind. But Allen Brenner (No. 86), posing with teammates Charlie Wedemeyer (No. 11) and Frank Foreman (No. 84), did it the old-fashioned way for MSU, averaging more than 50 minutes a game as the MVP of the Spartans' 5-5 1968 squad. One of the nation's last true two-way players, Brenner started at split end and safety, starring at both, and also played on special teams. Brenner was named All-America as a defensive back, but is believed to be the only player ever named Academic All-America on both offense and defense. Brenner also returned punts, and his 95-yard return against Illinois as a sophomore in '66 was tied for the Big Ten record heading into the 2003 season. Brenner did it all while caring for a wife and child and carrying a 3.77 grade-point average (on a 4.0 scale) as a pre-law major.

MOST INSPIRATIONAL. As Hawaii's prep athlete of the decade in the 1960s, Charlie Wedemeyer was called "Kalekauwila," which meant god of lightning. Wedemeyer started his Spartan career as a 5-foot-7 quarterback and ended it as a flanker who earned Outstanding Offensive Back honors as a senior in '68. Wedemeyer, shown with wife and interpreter Lucy at his side, will always be remembered as a giant of inspiration. After leaving MSU, Wedemeyer was hired to teach and coach at Los Gatos (Calif.) High School. In 1977, he was elevated to head football coach at the age of 31. However, about the same time he was also diagnosed with amyotrophic lateral sclerosis, Lou Gehrig's disease. Although he wasn't expected to live more than a year or two, he went on to coach the Wildcats to seven conference championships.

DOUBLE EXPOSURE. Ron (No. 70) and Rich Saul (No. 88) were identical twins in more way than one. Coach Duffy Daugherty use to make them smile before he called them by name because he could tell them apart by Rich's chipped tooth. Aside from looks, they also shared undeniable talent as college football players after leaving Butler, Pa., where they spent their summers working in coal mines. Ron earned All-Big Ten, All-America and team MVP honors as a guard in 1969, and Rich, who led MSU in tackles his last two seasons, was an all-league defensive end and linebacker. Both were Academic All-Americans, and became starters in their first years as pros. After leaving MSU, the Sauls followed older brother Bill into the NFL and both became All-Pros. Ron started as an offensive lineman with the Houston Oilers ('70–'75) and was a charter member of the "Hogs" with the Washington Redskins ('76–'81). Rich played center for the Los Angeles Rams ('70–'82). "I was All-Pro in 1979, but my greatest honor was earning Academic All-American," Ron once said.

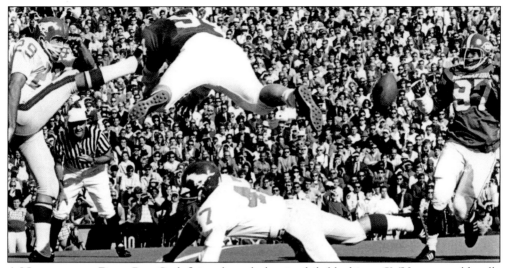

A NOSE FOR THE BALL. Ron Curl, flying through the air while blocking a SMU punt, could really get into an opposing team's hair. As an All-Big Ten sophomore defensive tackle in '69, Curl blocked four punts against SMU, Notre Dame, Ohio State and Iowa, and an extra-point. He missed the '70 season with a broken arm, but came back strong to earn All-America and All-Big Ten honors as a senior when he batted down four Michigan passes, blocked another punt and scored safeties against Notre Dame and Iowa. He also was third on the team with 89 tackles, including 45 solos. In a handwritten autobiographical note penned in '71, Curl provided a hint on how important winning can be to a high school recruit: "I picked MSU because they were #1 in the country at the time of my decision. I have no regrets and [am] very happy." The Spartans finished with a 6-5 record in '71, their only winning record during Curl's five seasons as a Spartan.

THANKS BORYS. Of the 16 longest field goals in Michigan State history, Borys Shlapak owns four. Only Morten Andersen, who came along ten years later, has more with five. Shlapak was MSU's first soccer-style place-kicker. As a junior in 1970, Shlapak kicked a 54-yard field goal against Northwestern. In '71, Shlapak had 54-yarders against Iowa and Minnesota and a 53-yarder versus Purdue.

A MIGHTY MITE NAMED "FLEA." Eric "The Flea" Allen would have been a natural in MSU's Pony Backfield of the mid-50s. At 5-foot-9, 161 pounds, Allen was a one-man stampede against Spartan opponents in '71 when he broke two NCAA records, four Big Ten marks and nine school standards. Allen's biggest claim to fame came on October 30 at Purdue when he rushed out of the wishbone for a then-NCAA record 350 yards on 29 carries in a 43-10 victory. Allen, being congratulated after his remarkable feat, also had touchdown runs of 24, 59, 30, and 24 yards. "This," wrote David Condon in *The Chicago Tribune*, "basically is the story of Eric Allen, who dodges, swivels, two-steps, ricochets when hit by a tackler, and drives defenses bananas." Allen, an All-American and Big Ten MVP in '71, became only the second Spartan to rush for 1,000 yards and with 1,283 of his 1,494 yards coming in eight conference games, Allen became the first player to reach 1,000 yards in league-only competition. "He changes direction so fast that he's only a blur in the films," said Coach Duffy Daugherty.

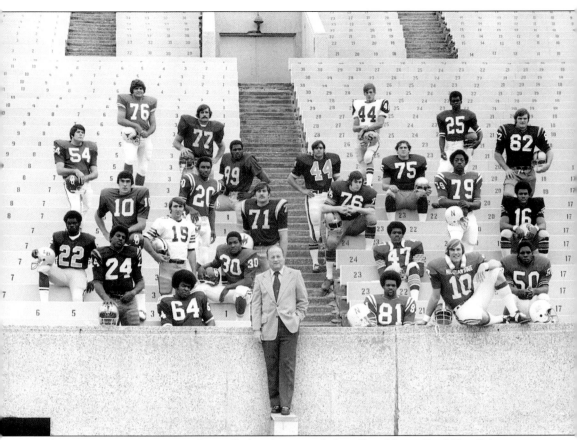

SATURDAY MATINEE IDOL. Ruggedly handsome and absurdly athletic, Brad Van Pelt was one of those guys who could have succeeded in just about everything he tried. Come to think of it, Van Pelt,—No. 10, pictured on wall with the Playboy All-American team and Nebraska coach Bob Devaney, a MSU assistant from 1954–1956—did. Van Pelt played on the Spartan basketball team, and though it was the weakest of his three sports, he was said to have NBA potential. He was such a fine right-handed pitcher, the California Angels drafted him when he was a MSU junior, and the St. Louis Cardinals made him their No. 1 pick in the secondary phase of baseball's free-agent draft in '72. But, Van Pelt excelled at football and was the first defensive back to win the Maxwell Award, which is given annually to the nation's top player. The first player chosen by the New York Giants in the '73 NFL draft, Van Pelt played 14 pro seasons as a linebacker for the Giants ('73–'83), Los Angeles Raiders ('84–'86), and Cleveland Browns ('86), and appeared in five consecutive Pro Bowls ('76–'80). "I have only two regrets in life, and one of them is that I wished I would have waited to sign my first pro contract with the Giants," Van Pelt, a member of the College Football Hall of Fame once said. "Because of that, I had to forgo my last seasons in basketball and baseball. I would've loved to been able to play those last seasons and earn nine letters. It's definitely something that if I could go back and do differently, I would."

JOE D. Before Joe DeLamielleure was inducted into the Pro Football Hall of Fame as part of the Class of 2003, he expressed tremendous pride in the fact that he was probably the only lineman to block for a running back who broke single-game rushing records in college and the NFL. DeLamielleure, MSU's All-American guard in '72, opened holes for Eric Allen when he ran for 350 yards against Purdue in '71. Five years later as a member of the Buffalo Bills "Electric Company" offensive line, DeLamielleure helped pave the way for O.J. Simpson who rushed for a league record 273 yards against the Detroit Lions. A three-year starter and two-time All-Big Ten selection, DeLamielleure played 14 NFL seasons for the Bills and the Cleveland Browns, and was an All-Pro in six of them. DeLamielleure joined Herb Adderley as the only Spartans in the Pro Football Hall of Fame.

THE LEGEND OF BILLIE JOE. Recognized as the greatest tight end in MSU history, Billy Joe DuPree proved his worth with precious few opportunities. He led the Spartans' run-oriented offense in receiving as a junior (25 catches, 414 yards, three touchdowns) in '71 and as a senior (23, 406) in 1972. Nevertheless, that was enough to get him noticed for All-America honors. DuPree had a career best eight catches, then tying the second-most by a Spartan in a game, for 134 yards in the loss to Southern Cal. DuPree, the last tight end to lead MSU in receiving, ended his collegiate career with 69 receptions, and then showed what he could really do during ten outstanding years with the Dallas Cowboys.

FOR KRYT'S SAKES. Before Michigan State played fifth-ranked and undefeated Ohio State in 1972, coach Duffy Daugherty moved a soccer-playing exchange student from The Netherlands up from the junior varsity because the 3-4-1 Spartans were struggling in the kicking department. Although Dirk Kryt asked whether he was "supposed to kick the ball under or over the whatchamacallitt," the job was his. And after 60 minutes, Kryt had to be everything—maybe the only thing—Buckeye coach Woody Hayes despised about football. Before halftime, Kryt set a Big Ten single-game record with the first four field goals—of 24, 40, 22 and 31 yards—of his life, plus an extra point to personally outscore Ohio State in the Spartans' 19-12 upset. The 24-year-old Kryt smoked cigarettes in front of coaches, drank beer, chased coeds, and wore his lucky blue soccer socks during games. It didn't occur to Kryt to get nervous before kicking against the Buckeyes. "Pressure?" said Kryt, who puffed away in the locker room after the game. "How can you feel pressure when you don't know what the hell's going on?" Woody must still be fuming.

OPPORTUNIST. Bill Simpson, talking to Detroit sportswriter Bill Halls, just had a knack. As a junior safety in '72, he scored in the season opener against Illinois on a 48-yard punt return and a 20-yard interception return. Against Purdue, Simpson ran stride-for-stride with Larry Burton all game long and held the Olympic sprinter without a catch. Simpson ended the season with a team-high-tying six interceptions. He also led the Big Ten in punt returns with an average of 13.6 yards per return. His 74-yarder against Georgia Tech was MSU's longest play of the season. He also had the team's longest punt, a 65-yarder against Michigan. As an All-American in '73, Simpson had a team-best five interceptions while leading a secondary that was ranked No. 2 in the nation, and a defense that was 12th overall. Simpson continued his fine play in the NFL with the Los Angeles Rams and the Buffalo Bills.

A BITTERSWEET FAREWELL. Late in the 1972 season, Duffy Daugherty announced that coaching football was no longer fun for him, and therefore his resignation would be effective after the final game of the season. "I feel that Michigan State deserves better than it has been getting," he said. Daugherty bowed out with a 24-14 victory over Northwestern. However, after going undefeated, winning the Big Ten, and in some quarters, a national championship in 1966, MSU went 27-34-1, in the ensuing six seasons. Daugherty's last of 19 Spartan teams finished with a 5-5-1 mark and Daugherty posted a 109-69-5 final record. Michigan State came close to hiring Oklahoma assistant Barry Switzer to replace Daugherty. Instead, the job went to Daugherty's defensive coordinator, Denny Stolz. Switzer eventually became the head coach at Oklahoma where he won three national championships. Stolz lasted three seasons, finishing no higher than third in the Big Ten and posting a 19-13-1 record overall.

FIVE

Great Players, Great Performances, Great Games

MILLER THE MAGNIFICENT. In 1987, defensive back John Miller intercepted four Michigan passes in MSU's 17-11 victory over Michigan, a Big Ten record and prime example of the virtuoso performances MSU has gotten in the 1970s, '80s, '90s, and 2000s.

While Michigan State has enjoyed only sporadic team success since Duffy Daugherty stepped down as coach in 1972, the stream of highlight-film performances and individual accomplishment has been fairly constant. There have been monumental upsets of: No. 1-ranked Ohio State in 1974, No. 4 Notre Dame in '83, No. 1 Michigan in '90, No. 4 Penn State in '97, No. 1 Ohio State in '98, No. 3 Michigan in '99, and No. 6 Michigan in '01. And, the list of players who have gained national acclaim is long, indeed.

Michigan State sent its 31st first-round draft pick to the NFL when the Detroit Lions picked wide receiver Charles Rogers, the school's only player to win the Biletnikoff Award, No. 2 overall in 2003. When John L. Smith became Michigan State's 23rd head coach on Dec. 19, 2002, he marveled at the pictures of Spartan All-Americans lining the walls of the football building, the national championships and Big Ten titles MSU had won, and the high profile the football program had maintained, sometimes in spite of itself, and wondered aloud why it hadn't accomplished more and couldn't think of a good reason why it couldn't in the future. And his appreciation of what it means to be a Spartans was growing. "We should spend time amplifying our tradition because we've had some great, great players and some great, great teams," Smith said. On September 6, 2003, Smith's second game as the Michigan State head coach was the program's 1,000th. Coincidentally, the Spartans hosted Rutgers—which played Princeton in the very first college game on November 6, 1869—while wearing the MAC emblem emblazoned with the number "1000" in the black and gold of Charlie Bachman's teams. Michigan State was referred to as the "Aggies" on the scoreboard and by the public address announcer. The significance of the milestone was not lost on Smith. "It's special from a tradition standpoint . . . for us not to forget the people who have come before us, and laid the stones for the path we get to walk on. If it weren't for them, we wouldn't be able to play this great game."

LEVI'S COMING. There are few Big Ten games that are more memorable than Michigan State's 16-13 upset of No. 1-ranked Ohio State on Nov. 9, 1974. The Spartans went into the game with an unimpressive 3-3 record and were trailing, as expected, late in the game, but by only an unexpected four points. And then, with just over three minutes to play, Levi Jackson, a sophomore fullback who ran a 100-yard dash in 9.6 seconds in high school, sprinted 88 yards up the right sideline for the touchdown that shocked the Buckeyes, and then the nation. The play began with quarterback Charlie Baggett. "It was a false squeeze play, where Baggett could give me the ball or pull it out and either keep it or pitch to (tailback Richie) Baes," Jackson told the *Lansing State Journal* in 1985. "He'd been pulling it out of my arms all day. This time, he left it in. I got through the line, made a cut to the right and was off to the races. Remember, I was really a tailback playing fullback." MSU sealed the victory with a goal-line stand on the final series, but controversy on the final play—did the Buckeyes score or didn't they?—delayed the final outcome for 45 minutes while Big Ten commissioner Wayne Duke conferred with game officials until darkness set in.

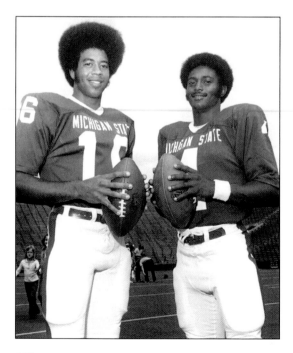

FAVOR RETURNED. Michigan State tried in vain to hire Knute Rockne away from Notre Dame on a couple of occasions, but still got an Irish lift when former Golden Domers Jim Crowley and Charlie Bachman agreed to coach the team. So, it was only right that MSU returned the favor when former Spartan quarterback and flanker Tyrone Willingham (right), pictured with quarterback Charlie Baggett, became the Irish head coach in 2002. The Spartans won three of four games Willingham started in place of the injured Baggett in 1973. Willingham's biographical sketch in the Spartan football media guided concluded with this line: "Hopes to be a coach."

ROGER THAT. Michigan State experienced a mini-resurgence when it hired Darryl Rogers away from the San Jose State Spartans to coach the MSU Spartans in 1976. Rogers brought a wide-open passing attack to the Big Ten and the Spartans took flight during his second season when they set a Big Ten record for offensive production and finished a half-game behind conference co-champs Ohio State and Michigan. With quarterback Eddie Smith running the show and All-American wideout Kirk Gibson running wild, MSU tied Michigan for the league championship in 1978 but couldn't go to the Rose Bowl because of NCAA probation. After the Spartans finished 5-9 in '79, Rogers left to become the head coach at Arizona State. Nevertheless, Rogers forever endeared himself to Spartan fans when he referred to the University of Michigan as "arrogant asses" at MSU's awards banquet.

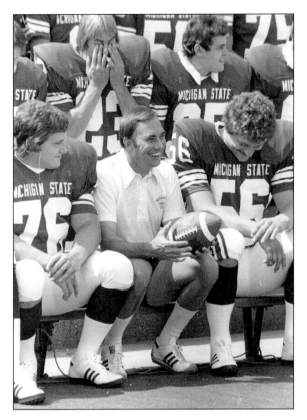

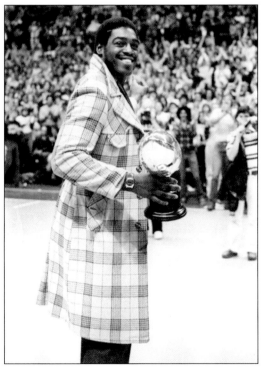

SACK MASTER. Defensive tackle Larry Bethea was ahead of his time. He specialized in sacking the quarterback long before the momentum-changing play got its due as one of the key elements of a football game. Bethea set the MSU single-season record with 16 sacks in 1977—all but two of his stops behind the line that season were on the quarterback—and he also holds the career record with 33 sacks from 1975–1977. Bethea was named first-team All-Big Ten and conference MVP.

101

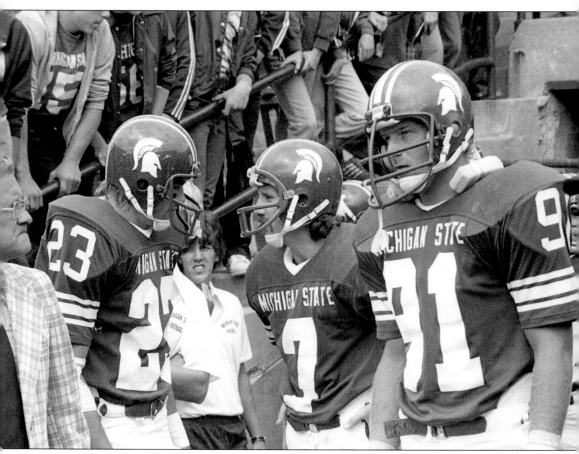

TREMENDOUS TROIKA. The Big Ten had never seen pyrotechnics until split end Kirk Gibson (No. 23), quarterback Ed Smith (No. 7) and tight end Mark Brammer exploded with offensive fireworks in 1978. Ohio State set the conference standard for total offense in '74 when it pounded out 493.2 yards per game, but that was done mostly on the ground. The '78 Spartans, at 481.2, proved a team could win in the heretofore earthbound Big Ten by passing the ball. With Gibson using his blazing speed to blow past defenders, Smith hitting targets with 58-percent accuracy and Brammer getting 360 tough yards on 33 catches, MSU piled up an average of 523.1 yards per conference game, a number that held up as the Big Ten record for league play through 2002. Brammer and Gibson earned All-America honors. Amazingly, while Smith topped the Big Ten in passing (130 of 224, 1,779 yards, 16 touchdowns, five interceptions) and total offense, and passed MSU to a 24-15 road win against Michigan—which shared the championship with the Spartans—he had to settle for second-team All-Big Ten honors behind Wolverine quarterback Rick Leach. In the head-to-head matchup in Ann Arbor, Smith completed 20 of 36 passes for 248 yards, no interceptions and two touchdowns, and also rushed for 36 yards for a total of 284 yards. Leach completed 5 of 15 for 98 yards, no touchdowns and three interceptions. He also had nine rushes for 50 yards and touchdown, for 148 total yards.

STACKING THE DECK. Ray Stachowicz added to MSU's punting tradition when he earned All-America honors as a junior in '79 with a Big Ten-leading 43.8-yard average. After leading the Big Ten again in '80, while finishing second nationally with a 46.2 average, Stachowicz became the conference's first four-time recipient of first-team All-Big Ten honors.

NICE CATCH. Except for linebacker Dan Bass (No. 49), not many Spartans did much in the 42-0 loss at Ohio State on October 27, 1979. Bass set a school record that still endures by tackling Buckeye ballcarriers 32 times. Bass, who was a consensus first-team All-Big Ten pick that season, had a knack for finding the runner. His 24 tackles against Notre Dame in '79 is third on the Spartans' single-game chart, and his 160 stops that season is fifth. Bass also is MSU's career leader with 541 tackles from '76–'79.

103

ALL TEED UP. When Spartan All-American place-kicker Morten Andersen put his tee down 63 yards from the goal post at Ohio State in 1981, Buckeye fans must have thought he was joking. But Andersen split the uprights with that kick, to set the Big Ten record that held up through the 2003 season. Before enjoying a long and productive NFL career, Andersen, shown nailing one from 57 yards against Michigan in '81, had kicked ten field goals of 49 yards or more for the Spartans.

COMEBACK KID. Cornerback James Burroughs couldn't play football for MSU in 1980 because he was declared academically ineligible. But he came back strong in '81. And, he performed pretty well on the field, too, earning All-America honors after leading the Big Ten's top pass defense with a then-school record 13 pass breakups. "At first, I thought it might be over," Burroughs told *The Lansing State Journal*. But Burroughs got his act together in the classroom by going to summer school. With the help of head coach Muddy Waters and assistant athletic director Clarence Underwood, Burroughs became one of MSU's proudest success stories.

A PASSMASTER. Michigan State didn't have much to brag about in the early 1980s, but quarterback John Leister put his name in the record books nonetheless. In addition to passing for more than 200 yards in four consecutive games in '80, he also smashed Eddie Smith's school record of 42 passes attempted against Minnesota in 1978 with 54 attempts against Purdue in a 36-25 loss. Two years later, Leister overtook Smith on his way to the top again. Leister's 32 completions (on 46 attempts), in a 31-17 loss, to Michigan bested Smith's mark of 27 against Notre Dame in '78.

TOUGH ENOUGH. In 1983, Michigan State turned a football team that had gone 10-23 during the previous three seasons over to former Spartan offensive lineman and assistant coach George Perles, shown with his beloved mentor and MSU coaching legend Duffy Daugherty. The architect of the famed Steel Curtain defense that led the Pittsburgh Steelers to four Super Bowl titles, Perles built his Spartan program on a simple premise—just be tough. And, his Spartans were. They won the outright Big Ten championship and the Rose Bowl during the '87 campaign. The Perles-led Spartans were Big Ten co-champs and John Hancock Bowl winners in '90. Perles wanted his program to be the bridge back to the glory days of Biggie Munn and Daugherty. Like Munn, Perles wasn't politically correct from the start and often spoke from the heart, especially after his first recruiting battle with Michigan for in-state talent in '83. "We knocked their socks off," Perles said. "I think we're back in control in Michigan." And like Daugherty, he treated Spartan faithful to some of the best times they ever knew, particularly with a stunning upset of No. 1 Michigan in Ann Arbor in '90. Perles posted a 68-67-4 record as the MSU head coach and was 4-8 against UM.

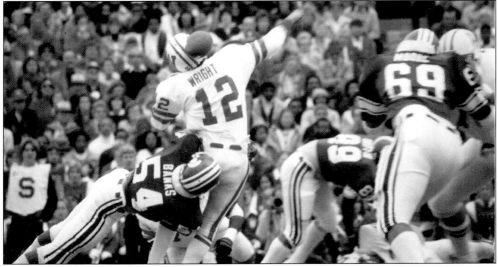

BACKBREAKING LINEBACKER. Ball-carriers could run, but they couldn't hide from Spartan outside linebacker Carl Banks (No. 54). An All-American in '83 and the first non-kicker to earn first-team All-Big Ten honors in three consecutive seasons, Banks led MSU with 86 tackles even though teams rarely ran to his side. And yet, the number disappointed some, though Banks explained, "I can't help it if they're running in the other direction and I'm not making as many tackles." Banks never had to explain himself in the NFL where he starred for the New York Giants and Washington Redskins.

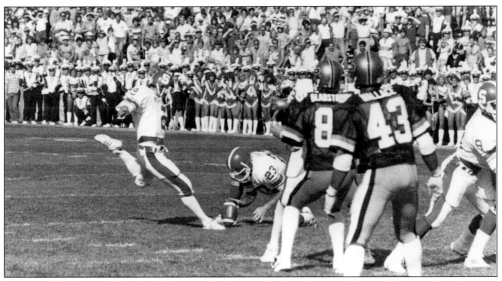

LETHAL WEAPON. Michigan State coach George Perles often said he could win a lot of games with a good defense, a reliable running back and a great punter. Ralf Mojsiejenko was Perles' first great punter. Mojsiejenko averaged 43.9 yards per punt and nailed 71-yarders against Notre Dame and Wisconsin while earning All-America honors in '83. A native of Salztgitter, West Germany, Mojsiejenko was also a dangerous long-range place-kicker. His last-second, 59-yard field goal gave MSU a 29-29 tie with Purdue, and his 61-yarder against Illinois in '82 is the fourth-longest in Big Ten history. "He's the kind of guy that should be outlawed in football," said Michigan coach Bo Schembechler. "You know, when you can go beyond the 50-yard line, that's too much."

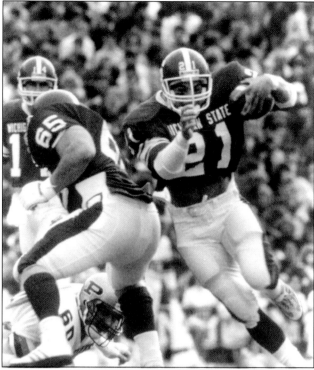

. . . AND THE LAST SHALL BE FIRST. Fullback Bobby Morse was the last member of MSU coach George Perles' first recruiting class and first in the hearts of Spartan fans in '84. His 87-yard punt return for a touchdown against Michigan just before halftime in Ann Arbor boosted MSU to a 19-7 victory. It was Perles' first victory against the Wolverines and the Spartans first win over UM since 1978.

PASSING FANCY. They said it would never happen. But, in 1986, after star tailback Lorenzo White sustained a leg injury, MSU led the Big Ten in passing under coach George Perles who maintained three things can happen when the ball is thrown and two of them are bad—an incompletion or an interception. Dave Yarema was the triggerman, throwing for a then-record 2,581 yards. His completion rate of 67.3 percent (200 of 297) remains a school record. Perles wasn't convinced, however, because the Spartans finished 6-5 and out of the bowl picture.

MAN MOUNTAIN. At 6-foot-7, 316 pounds, and the ability to run a 40-yard dash in a verified 4.65 seconds during a pre-NFL draft workout, Spartan offensive tackle was a sight to behold. "I could have run a 4.5 today, but I didn't want to pull anything," Mandarich said. He once drove a defensive lineman 20 yards downfield and after knocking him to the ground in the end zone, pointed at him and said, "Why don't you just stay there." Mandarich opened the holes and Lorenzo White ran through them. It was as simple as that. An All-American in '87, Mandarich was the first-round draft pick of the Green Bay Packers, but enjoyed only a checkered professional career.

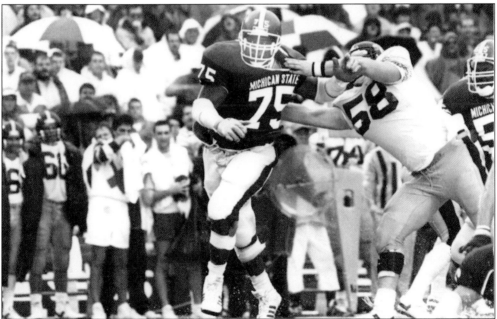

WREAKING HAVOC. The Big Ten began recognizing quarterback sacks as a individual statistical category in 1987, and Spartan defensive tackle Travis Davis was the league's first sack champion with an even dozen for minus-105 yards. Davis set a school record with five sacks in the pivotal 13-7 victory at Ohio State. After the Buckeyes scored on the first play of the game, the Davis-led defense shut them out in the final 59 minutes.

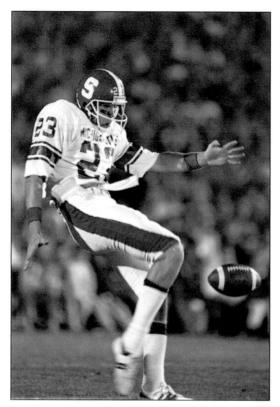

THE MONTGOMERY MORTAR. Although he only appeared in a few plays a game at most, Greg Montgomery was as integral as any other Spartan during MSU's run to the '87 Big Ten championship. A two-time All-American, Montgomery repeatedly kicked the Spartans out of jams, the defense kept the opposing offense bottled up in its own end and the Spartans often got the ball back in with good field position. In 1986, Montgomery established a school record with a 47.8 average, which was boosted by a MSU record 86-yarder against Michigan. His average would would rank third all-time in the Big Ten, but he fell one short of the minimum of 40 punts to qualify. As a senior, Montgomery averaged 44.7. Montgomery's career average of 45.2 yards ranks second in the Big Ten, just behind that of Iowa punter Reggie Roby's 45.5.

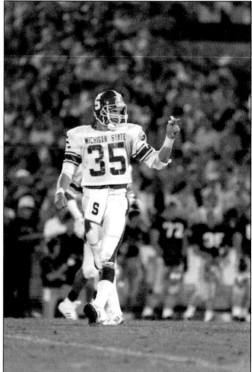

IT TOOK A THIEF. In 1987, a heady player named Todd Krumm led the Big Ten and set a Michigan State record with nine interceptions. His 18 picks are second on MSU's all-time list behind Lynn Chandnois' 20. Krumm was a versatile performer. When injuries took a toll on the Spartan secondary, Krumm switched from safety to cornerback even though he wasn't blessed with great coverage speed. He also led the team in punt returns in '86 and '87.

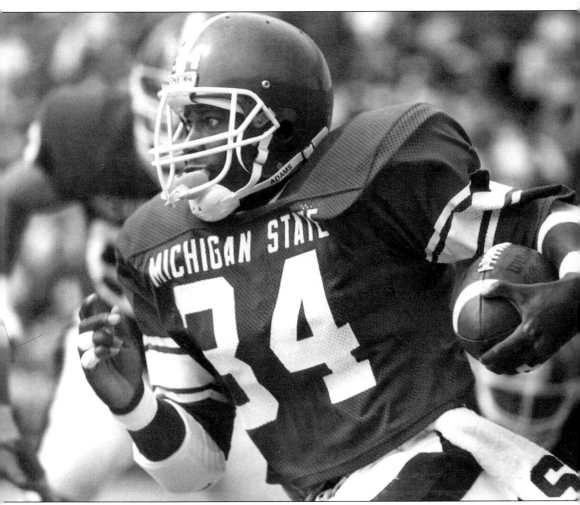

LO AND BEHOLD. Spartan tailback Lorenzo White did not have tremendous straightaway speed. What White had was the ability to run as fast sideways as he did forward. In 1985, White rushed for 1,908 yards during the regular season, which at the time was the fourth-best running performance in college history. He added 158 yard in the All-American Bowl to finish with 2,066 yards and become the first Big Ten runner to reach 2,000 yards in a single season. He won All-America honors and had he been a senior might have won the Heisman. But, as a sophomore he finished fourth in the voting. As a senior in '87, White gained more than 200 yards in four games, including 286 in the Big Ten championship showdown with Indiana. His 1,572 yards were instrumental in getting MSU to the Rose Bowl for the first time in 22 years, though White, who owns the two greatest single-season rushing performances in Spartan history, again finished fourth in the Heisman balloting. White still holds school records for career attempts (1,082,), career yards (4,887), career rushing touchdowns (43), single-season attempts (419, also a Big Ten record), single-season yards (2,066), and single-game attempts (56 vs. Indiana in '87).

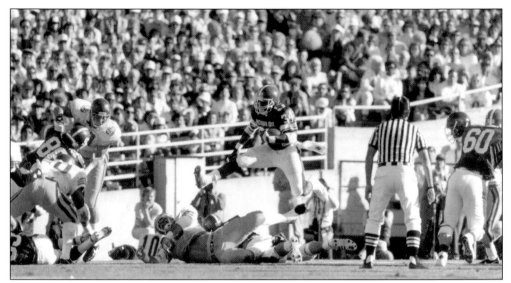

JINX BUSTERS. The George Perles era reached the high-water mark with a 20-17 victory over Southern Cal in the Rose Bowl while snapping a six-game Big Ten losing streak to the Pac-10. Michigan State was only the second Big Ten team to win in Pasadena in 14 games. The Spartans began and ended the season with victories over USC to finish with a 9-2-1 record and No. 8 ranking, its best showing since 1966 when it was 9-0-1 and No. 2. The Spartans also improved to 3-1 in Rose Bowl games.

GETTING IT DONE. Michigan State and Southern Cal were tied at 17 when Spartan quarterback Bobby McAllister rolled to his right on third-and-8 at the Spartan 30-yard line. With McAllister running out of real estate, he leaped in the air and launched a pass, while soaring out of bounds, that Andre Rison caught for a 36-yard gain. Six consecutive rushes by Blake Ezor moved the ball 26 yards to the Trojan 18-yard line and a 36-yard field goal by freshman John Langeloh (No. 10), shown celebrating with holder Greg Montgomery, proved to be the game-winner with 4:14 remaining. MSU weathered the final minutes in part because Todd Krumm recovered a fumble by Trojan quarterback Rodney Peete, and John Miller intercepted Peete's final desperation pass. Langeloh tied the school record with 17 field goals in '87, established a new mark with 18 in '88 and kicked a school record 10 extra points against Northwestern in '89. His 308 points are the most in school history and he also holds the MSU career field-goal record with 57 (79 attempts) and PAT mark with 137 (140 attempts).

DIAMOND IN THE ROUGH. Kurt Larson was the perfect example of how MSU coach George Perles and his staff were able to take lesser-known, and sometimes totally ignored or obscure, prospects and turn them into bona fide Big Ten players. Perles recruited Larson to be a place-kicker, and he ended up as one of the best linebackers the school has ever had. Larson intercepted eight of his 14 career passes in '88 and was named second team All-Big Ten.

"BAD MOON" RISON. Few Spartans have made the more of limited opportunities than Andre Rison. Had he played for a pass-oriented team, he might have been the greatest receiver of all time. But, he played for Michigan State, which under George Perles, favored the run 3 to 1 over the pass. Even so, Rison managed to earn All-America honors in '88—with the Spartans attempting just 13 passes a game—on his meager allowance of just 39 receptions, which he parlayed into 961 yards. Rison went out with a bang, catching nine passes for a then-school record 252 yards against Georgia in the Gator Bowl. A former first-round pick, Rison had a flamboyant NFL career.

LORD HAVE MERCY. Michigan State middle linebacker Percy Snow was a collision waiting to happen. Built like a mighty oak from the waist down, Snow could really lay the lumber on ball-carriers. "Hitting is just something I enjoy doing," said Snow, who began his sojourn to becoming MSU's most decorated player by winning MVP honors in the '88 Rose Bowl as a sophomore. He was an All-American as a junior and again as a senior in '89 when he also became the first player ever to be given the Butkus Award and the Lombardi Trophy, which was presented to him by former Kansas and Chicago Bear great Gale Sayers. Snow's 473 tackles are second only to Dan Bass, on MSU's career list. Snow's younger brother, Eric, was a standout MSU basketball player and a solid NBA performer.

'DA BANG STICK. Harlon Barnett's father, Carlis, wanted his son to have a distinctive nickname that summed up his football prowess. "You remember they used to call Fred Williamson 'The Hammer'," Carlis once told a reporter. "Well, I came up with 'The Bang Stick,' which is basically an underwater cattle prod. You hit a shark with it, and it's all over for him. Same with Harley. If he hits you right, he'll knock you out." Barnett (No. 36) lived up to his moniker by earning All-America honors in '89. With Barnett playing cornerback, MSU led the Big Ten and was 11th nationally in rushing defense and total defense. He returned one of his three interceptions 35 yards for a touchdown against No. 2-ranked Miami.

KULA BEAR. As a senior in 1989, Bob Kula also could have been known as "The Encore." After Tony Mandarich ran out of eligibility, Spartan coaches decided to fill those large shoes by moving Kula from left guard to left tackle. "I don't think I've had an outstanding or super season, but I've played consistent," Kula said. The experts begged to differ, rewarding Kula with All-America honors. With Kula blocking, MSU scored a Big Ten-best 37 rushing touchdowns.

BALL HAWK. Michigan State didn't get its first 1,000-yard receiver until 1989 when Courtney Hawkins caught 60 passes (then a school record) for 1,080 yards. Hawkins completed his career in '91 with 138 receptions, which is No. 2 on MSU's all-time list. Hawkins was first-team All-Big Ten in '89 and '91, but he completed the '90 season with MVP honors in the Sun Bowl after making six catches for 106 yards and a touchdown in the 17-16 victory over Southern Cal.

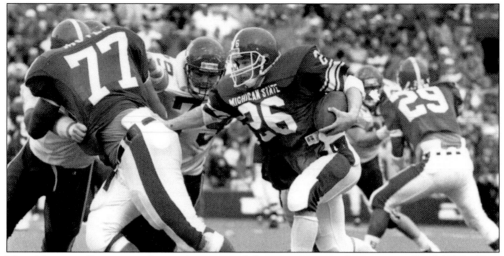

NOT EXACTLY PEANUTS. Ounce for ounce, 5-foot-9, 190-pound Spartan tailback Blake Ezor was one of the toughest Spartans ever. Maybe it was a survival technique, but Ezor had a sneaky way of delivering a punishing blow on the tackler before the tackler could unload on him. Oddly enough, Coach George Perles used to refer to Ezor by saying, "He's Peanuts," referencing the comic strip because of his wide-eyed naivete. In the '89 game against Northwestern, Ezor scored a then Big Ten record six touchdowns. His 1,496 yards in '88 is third on MSU's single-season rushing chart and he gained 1,299 in '89. Ezor picked up 3,749 yards in his career, good for third in Spartan history.

NO. 1 VS. NO ONE. In 1990, MSU took a 1-2-1 record into Ann Arbor to face No. 1-ranked Michigan. With Spartan running backs Tico Duckett and Hyland Hickson pounding the Wolverine defense and MSU linebackers Carlos Jenkins and Dixon Edwards wreaking havoc on the UM offense, the game was a closely contested classic even before the final six seconds. After Duckett put the Spartans up 28-21 with 1:59 remaining, quarterback Elvis Grbac marched the Wolverines right back and hit Derrick Alexander with a 7-yard touchdown pass to pull to within one with six seconds left. Michigan coach Gary Moeller could have kicked for the tie, but decided to go for the win with a 2-point conversion. However, as wideout Desmond Howard slanted into the end zone, Spartan cornerback Eddie Brown (No. 24) defended—or did he interfere?—Grbac's pass, which Howard dropped in the end zone. After Michigan recovered the onside kick, Brown intercepted Grbac's Hail Mary to end the game and become Public Enemy No. 1 in Ann Arbor.

GREEN GENES. With a name like
Bullough, you better play for Michigan
State and you better play well. Chuck
(No. 41), the second son of Hank
and younger brother of Shane, set a
single-season school record with 175
tackles—three more than the mark
established by Percy Snow two years
earlier. In 1990, Chuck had 164 stops,
which is tied with Snow (1988) for
the third-most. Shane, also a middle
linebacker, has the sixth highest single-
season total with 156 tackles in '85.
Chuck (391) and Shane (311) are fifth
and 13th on MSU's career tackle list.
Henry was a standout Spartan lineman
in the '50s and is the only player to
play all 60 minutes in a Rose Bowl.

MR. ACCURACY. From 1990–1993,
Spartan quarterback Jim Miller
completed 467 passes, the most in
MSU history, but only attempted 746,
which is the fourth-most. According
to the math, Miller completed
62.9-percent of his throws, which
is the best of any Michigan State
quarterback. Only three Spartans have
ever completed 30 or more passes in
a game, and Miller did it twice. He
posted 31-of-42 accuracy against Ohio
State in '93 and went 30-for-39 against
Michigan in '91.

117

THE TICO-HYLAND EXPRESS. Before Tico Duckett (No. 35) came along, no Spartan had ever rushed for 1,000 yards in three seasons, let alone consecutively. Duckett gained 1,394 yards and led the Big Ten as a sophomore in 1990, 1,204 yards in '91 and 1,021 in '92. Duckett's 4,212 yards is second only to Lorenzo White on MSU's all-time list. In 1990, Duckett and the late Hyland Hickson (No. 30), who gained 1,196 yards, comprised only the second backfield in Big Ten history to feature a pair of 1,000-yard rushers.

THE GREAT AND MYSTERIOUS SA-BAHN. In 1995, former Spartan defensive coordinator and NFL rising star Nick Saban was hired as MSU's 20th head coach with the charge of breathing new life into a moribund program. Noted for his unyielding intensity, he did just that by never having a losing season in the five he coached the Spartans and taking MSU to four bowls. Saban left for LSU with a 34-24-1 record at MSU.

MASON MADE HIS CASE. Derrick Mason is arguably the greatest kickoff returner in Big Ten history. His 2,575 yards from 1993–1996 tops the conference career list and are nearly 500 more than the second-place returnman. Mason also holds the league record with 106 career returns. He ranks second on the single-season list. However, Mason got his 966 yards on 36 returns in 1994, while Iowa's Earl Douthitt had 994 on seven more returns in '73. Mason also holds down the No. 3 spot with 947 yards on 35 returns in '95. Mason holds MSU single-game records for kick and punt-return yardage and his two kick returns for touchdowns—versus LSU in the 1995 Independence Bowl and against Penn State in '94 — both covered the maximum 100 yards.

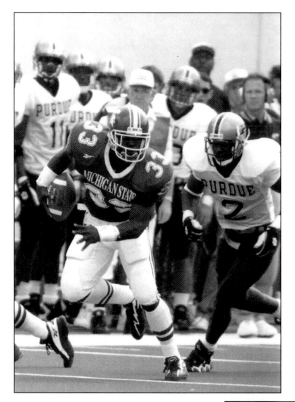

SWERVIN' IRVIN. Sedrick Irvin burst onto the scene and ESPN's highlight film by scoring four touchdowns against Purdue in his freshman debut. Irvin became the first Spartan rusher to gain 1,000 yards in each of his first three seasons, and the second to rush for a grand in three consecutive campaigns. Irvin left after his junior season to pursue a professional career. Had he stayed, he might have been MSU's all-time leading rusher. He is fourth with 3,504 yards, just 1,383 behind Lorenzo White.

MSU BANKED ON IT. In a 1998 Internet poll, MSU fans voted Michigan State's 28-25 victory over Michigan on November 4, 1995 the greatest game in Spartan Stadium history. It was first-year coach Nick Saban's first game against UM, so it was significant from that standpoint. But, fans were on edge all game long until junior college-transfer quarterback Tony Banks (No. 12) hit Nigea Carter with the game-winning touchdown pass with 1:24 remaining. His 93-yard touchdown pass to Carter against Indiana in '94 is the longest in school history.

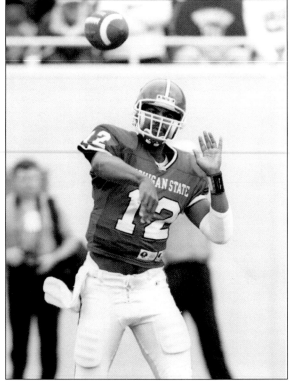

WELCOME TO HOTEL FLOZELL. Flozell Adams was so big at 6-foot-7, 330 pounds, teammates called him "Hotel." "It just rhymes," said Adams, who hated the nickname. Nevertheless, Adams was a high-rise that defenders had a hard time getting over or around. Adams allowed only two sacks during his All-American senior year in 1997. The Dallas Cowboys picked Adams in the second round of the NFL draft.

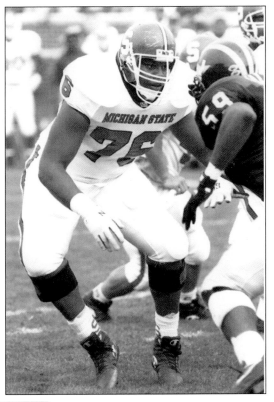

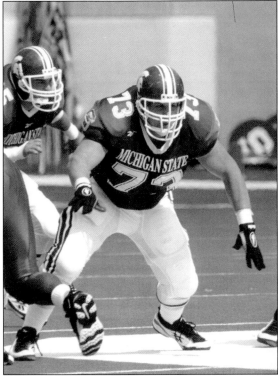

SHAW LANE. The road that passes in front of Spartan Stadium is Shaw Lane. It's not named for former MSU offensive guard Scott Shaw, but they could have used him as a road-grader while constructing it. Shaw was one of two All-American Spartan offensive linemen in '97, when MSU was 24th nationally in rushing. Shaw started all 12 games, and allowed only one sack.

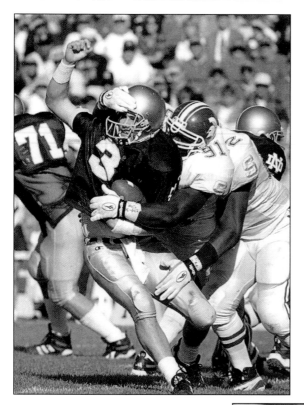

ANOTHER SMITH. It was only natural that when Robaire Smith arrived at MSU to play defensive end he'd be compared to all-time Spartan great Bubba Smith. To his credit, Smith lived up to expectations. After his junior, and final, season in '98, Smith also earned All-America acclaim. He was fourth on the team with 52 tackles, and had a team-high eight tackles behind the line, including two sacks despite getting extra attention every game. "If I get past one guy, there's a second guy, and if I get past him the back is there," Smith said. It was no different for Bubba.

OPPORTUNITY KNOCKED, PETERSON ANSWERED. When defensive end Robaire Smith broke his leg in the first quarter of MSU's game against No. 1 Ohio State in Columbus in 1998, all seemed lost for the Spartans. But, that just meant coach Nick Saban had to rely on Julian Peterson as more than just a situational player on passing downs. Peterson was spectacular, causing fumbles, and chasing down Buckeyes with his amazing closing speed. The Spartans pulled off another shocking upset, this time by a score of, 28-24 and Peterson's star was born. As a senior in '99, Peterson set a MSU record with 30 tackles behind the line, including 15 sacks. He was the defensive MVP in the Spartans' 37-34 Citrus Bowl victory over Florida. Although he played only two seasons before becoming a first-round pick of the San Francisco 49ers, Peterson set a MSU career record with 48 tackles for loss.

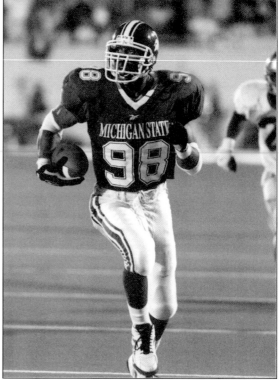

A CASE FOR BURKE. When Spartan fans talk about the greatest quarterbacks in MSU history, Bill Burke's name is conspicuous by its absence. But a case can be made that he should be listed very near the top. During the 1999 season, Burke led the Spartans to only its second 10-win season, including a 37-34 victory over Florida in the Citrus Bowl. He became the first MSU passer to reach 400 yards yards in a game while leading the Spartans to a 34-31 victory over Michigan. He set a school record for most passing yards in a season with 2,595 in 1998, and his 46 touchdown passes was also a school career record.

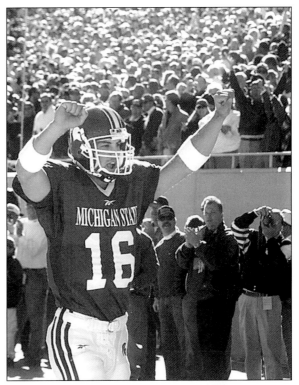

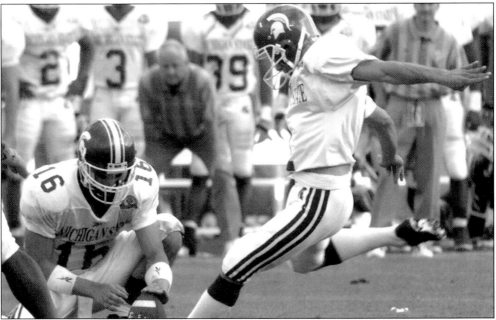

CLOSE TO THE EDGE. Paul Edinger added to MSU's fine tradition of place-kickers when as a junior in 1998 he ranked third in the nation with an average of two field goals per game to earn All-America honors. But, he waited until the final seconds of his last game as a Spartan to kick the first game-winning field-goal of his football career, high school or college. Edinger kicked the 39-yard field goal to beat Florida, 37-34, as time expired in the 2000 Citrus Bowl.

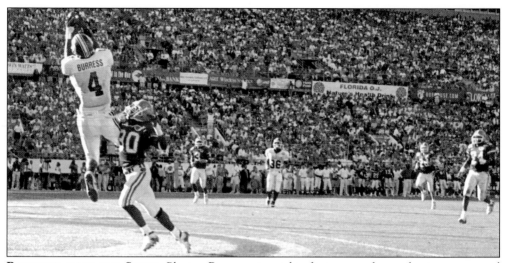

BURSTING ONTO THE SCENE. Plaxico Burress sat out his first season for academic reasons and left a year early to enter the NFL draft. But did Burress ever make things happen during the two intervening seasons. Burress was the first Spartan to record 1,000 receiving yards in two seasons (1998–1999). He set the school record for catches with 65 as a sophomore and broke it with 66 the following season. His 12 touchdown catches in '99 also was a school record, as were his 255 yards against Michigan that season. Burress' 13 catches—for 185 yards and three touchdowns—against Florida in the 2000 Citrus Bowl remains No. 1 on MSU's single-game list.

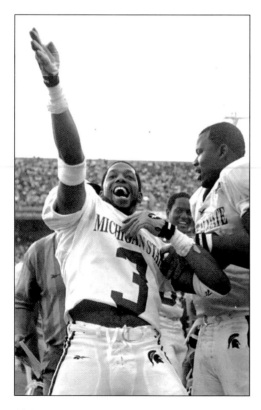

SOUP'S ON. Amp "Soup" Campbell's career came to screeching halt in the second game of the 1998 season at Oregon when he sustained a severe neck injury while making a tackle. Campbell experienced numbness in his arms, fractured two vertebrae, and initial reports were that Campbell was lucky not to sustain permanent paralysis. "He was millimeters away from having some kind of serious (spinal) cord injury," said MSU head trainer Jeff Monroe. After undergoing surgery to fuse the damaged bones and wearing a body brace for three months, Campbell's outlook improved to the point of being able resume a normal life. Nevertheless, it was nothing short of amazing when Campbell returned to the field as a defensive back in '99, and in the rematch against Oregon in Spartan Stadium returned a fumble 85 yards for the winning touchdown with 14:08 remaining in the game. "I've never felt lower as a coach (than) when he got hurt," said MSU coach Nick Saban. "I've never felt higher than when he picked up that fumble and ran it back."

BOWLED OVER. It is significant that one of the four African-American head coaches in Division I-A college football at the time worked for Michigan State. But Bobby Williams made a statement in other ways, as well. After taking over for the hastily departed Nick Saban at the end of the 1999 season, Williams led the Spartans to a 37-34 victory over Florida in the Citrus Bowl. And in 2001, Williams coached MSU to a 7-5 record that included a 44-35 bowl victory over Fresno State in the Silicon Valley Football Classic. Williams and Biggie Munn are the only two MSU coaches to be undefeated in postseason games.

HEY, HE WAS GOOD. A highlight film of Herb Haygood's greatest plays would be more than a short subject. Against Notre Dame in 2000, Haygood turned an 11-yard slant on fourth down into a game-winning 68-yard touchdown catch-and-run with 1:48 remaining. In 2001, Haygood became the only player in MSU history to return kickoffs for touchdowns in consecutive games—84 yards against Northwestern and 100 versus Iowa. Haygood was the first kickoff returner to be named to the Walter Camp All-America Team.

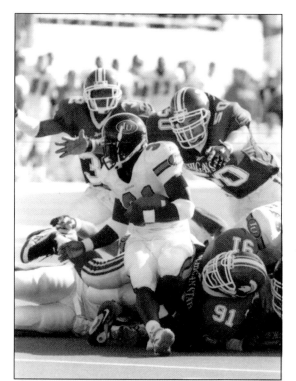

A CHIP OFF THE OLD BLOCK.
When your father is one of the most venerated sports figures in school history and he goes by the name of "Mad Dog," it could be a tough act to follow. But, Spartan middle linebacker Josh Thornhill (No. 50) pulled it off with style and class. Chiseled out of the same block of granite used for his father, Charlie, Josh anchored the MSU defense for three seasons and was first-team All-Big Ten as a junior and senior. Thornhill's 395 tackles is fourth on MSU's all-time list and his 33 tackles for losses is tied for fifth with Juan Hammonds.

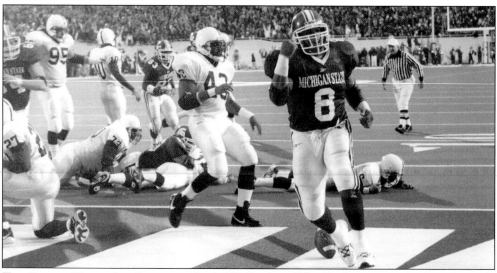

THE DIESEL. To say that Spartan tailback T.J. Duckett (No. 8) , known as "the Diesel," made an impact would be an understatement. He left countless dented tacklers in his wake while barreling for 3,379 yards and 29 touchdowns—fifth-best and fourth-best, respectively, in school history—for three seasons from 1999–2001. Duckett, the younger brother of former MSU rushing star Tico, contributed two of the most memorable plays in the annals of Spartan football. As a freshman, his multiple-tackle breaking, 11-yard touchdown run with 2:30 remaining was the difference in a 35-28 victory over 13th-ranked Penn State. And, against No. 6 Michigan in 2001, his catch of Jeff Smoker's 2-yard touchdown pass, which gave MSU a 26-24 win as time expired remains the subject of much debate all over the state of Michigan.

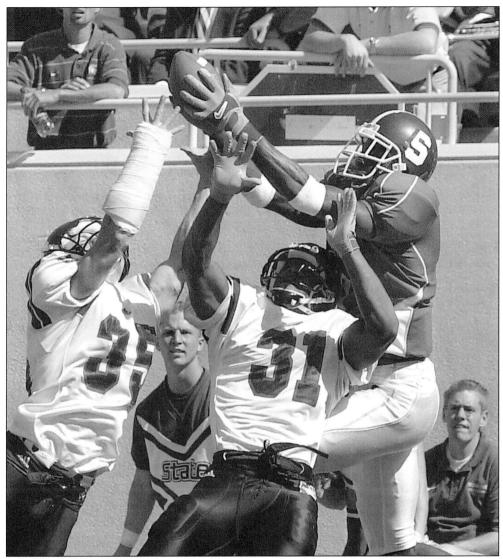

CHARLES IN CHARGE. All-American wide receiver Charles Rogers kept Michigan State's name in the national limelight in 2002 even though the team struggled to a disappointing 4-8 record. He broke consecutive-game touchdown records with this 21-yard touchdown reception from Jeff Smoker in the 39-24 victory over Northwestern. He had at least one touchdown grab in 13 consecutive regular season games, for the NCAA mark, and one in 14 games in a row, including postseason, for the Big Ten standard. Rogers' 1,470 receiving yards in 2001 is second on the Big Ten's single-season list to Wisconsin's Lee Evans (1,545, also in '01), and with 1,351 yards in '02, Rogers also has the two best single-season receiving performances in MSU history. His 68 catches in '02 and 67 catches in '01 also are Nos. 1 and 2 in the Spartan record book as are his 14 TD grabs in '01 and 13 in '02. Rogers' 270 receiving yards against Fresno State in the 2001 Silicon Valley Classic also broke Plaxico Burress' single-game school record of 255 yards. Three All-Americans top the Spartans career receiving yardage chart: Andre Rison with 2,992, Rogers (2,821) and Kirk Gibson (2,347). After becoming the only Spartan to win the Biletnikoff Award, Rogers passed up his final year of eligibility to become the No. 1 NFL draft choice—the 31st in school history—of the Detroit Lions.

THE JOHN L. SMITH ERA BEGINS. Smiths have been very good for Michigan State. Gideon, Bubba, and Robaire are among the most significant of all time. John L. Smith, the school's 23rd head coach, would like nothing better than to add to that tradition. Smith came to MSU for the 2003 season as the 14th-ranked winningest active Division I coach with a record of 110-60 in 14 seasons at Idaho, Utah State, and Louisville. A linebacker and quarterback at Weber State (pictured below), Smith is banking on returning the Spartans to prominence with a wide-open passing offense, attacking defense and an energetic personality. He began his career as a Spartan with a 26-21 win over Western Michigan. Smith's first Spartan team completed one of the nation's biggest turnarounds with an 8-5 overall record, 5-3 Big Ten mark, and Alamo Bowl appearance.

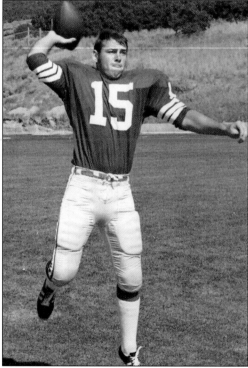